Painting Landscapes

IN OIL

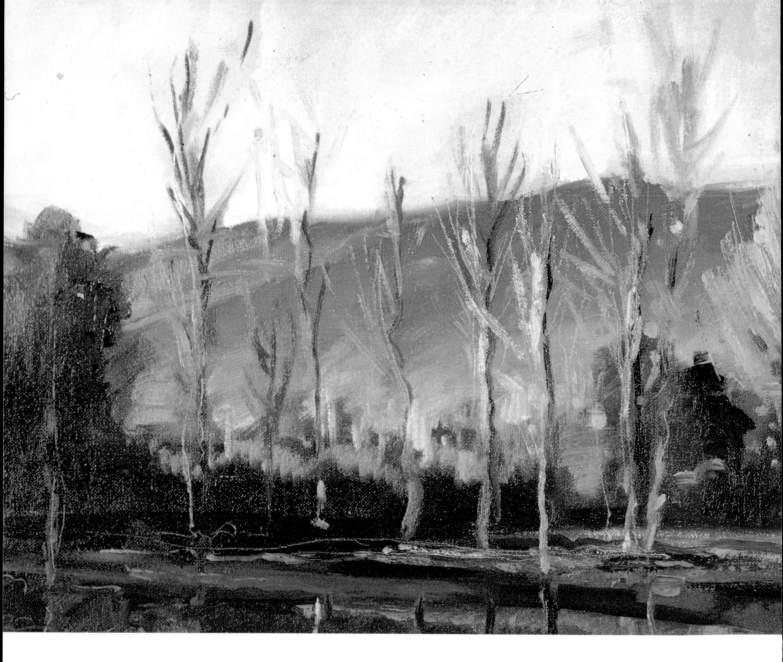

All inquiries should be addressed to:
Barron's Educational Series, Inc.
250 Wireless Boulevard
Hauppauge, New York 11788

Library of Congress Catalog Card No. 94-49011

International Standard Book No. 0-8120-9291-0

Library of Congress Cataloging-in-Publication Data
Paisajes al oleo. English
 Painting landscapes in oil.
 p. cm. —(Easy painting and drawing)
 Author : Parramón Ediciones Editorial Team, illustrator :
Miquel Ferrón—T.p. verso.
 ISBN 0-8120-9291-0
 1. Landscape painting—Technique. I. Parramón Ediciones.
 II. Title. III. Series
ND1342.P2713 1995
751.45'436—dc20 94-49011
 CIP

Printed in Spain
5678 9960 987654321

EASY
Painting & Drawing

Painting Landscapes

IN OIL

BARRON'S

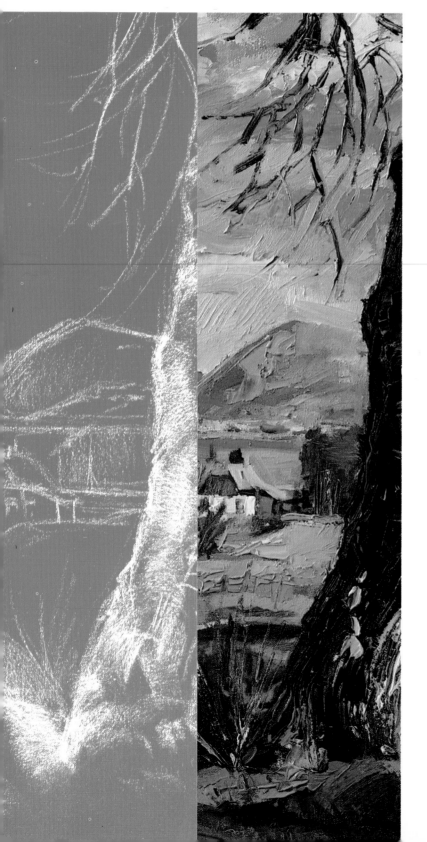

CONTENTS

Introduction **5**

Oil Painting Materials **6**

Oil Painting Techniques **10**

Exercises

Painting a Landscape of Fields **16**

Painting a Snow-Covered Landscape **24**

Painting a Valley **32**

Painting an Atmospheric Landscape **40**

Painting a Reflected Landscape **48**

Painting with a Palette Knife **56**

Acknowledgments **64**

I would like to begin by congratulating you on choosing this book on oil painting. Oil is the king of all mediums because of its unique characteristics and the prominence that oil has acquired throughout its long history. As you may already know, oil paints have a great wealth of tones. Just a few colors, mixed in varying proportions, can create an infinite range. Oil paints are opaque and are normally applied on a canvas or linen support.

Unlike other mediums, oil paints will help you develop your work, constantly compel you to experiment, and help you to discover and master an endless number of colors, hues, compositions, styles....

To enter the world of painting is to enter an artistic world with infinite possibilities. It is the start of a new adventure, requiring daring and tenacity, among other qualities. But you will be rewarded with pleasant surprises and satisfaction. There is a lot to learn in this difficult medium. However, don't despair. The most important thing is to get started. But don't stop now. You learn to walk by walking; by continuing to walk, you will reach your goal. In spite of the obstacles, keep walking. The advice given is important, the techniques shown are necessary. But in addition to these fundamentals, practice is essential. With stamina, willpower, and courage you will reach your goal.

I hope this book will inspire you to keep on painting when you have mastered the techniques shown here. Good luck.

Jordi Vigué

OIL PAINTING MATERIALS

*T*his chapter introduces the basic materials and tools you will use to paint in oil. Let us begin by looking at colors. They are sold in varying sizes, according to the brand. These sizes are indicated on paint tubes in both fluid ounces (fl. oz.) and either cubic centimeters (cc) or milliliters (ml). The most common types come in quantities of 20–25 cc, 35–40 cc, or 60 cc. White, however, is generally sold in larger quantities: 115, 120, 150, or 250 cc. The larger sizes are usually sold to professionals who use large amounts of this color.

A

In figure A we can see an oil painting case consisting of a palette, brushes (numbers 4, 8, and 12), and a selection of colors: titanium white, medium yellow, yellow ochre, vermilion, madder, turquoise blue, ultramarine deep, cadmium green, emerald green, raw umber, and cobalt light. This selection can be varied according to taste and needs.

ACCESSORIES

The accessories you will need depend on whether you are working in the studio or outdoors. Here we have provided those that are used in both situations: rags and old newspapers to clean your brushes and tools (B), rectified turpentine, fast-drying medium, palette cups (D), palette knives (E), and charcoal (F).

BRUSHES

There are different types and qualities of brushes. From left to right (G), flat synthetic bristle brush, round sable brush, flat sable brush, ox-hair filbert brush, round hog-bristle brush, hog-bristle filbert brush, and flat hog-bristle brush. These brushes come in various sizes, generally from 0 to 22, and then go up in even numbers (0, 2, 4, 6, 8, 10, 12, etc.). If you are not sure which brush is best for a specific purpose, ask your local art store dealer for advice.

B

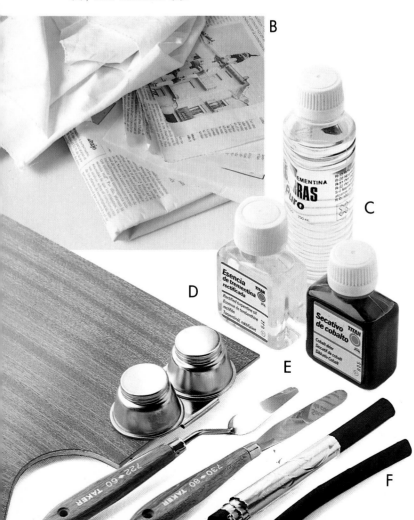

C

D

E

F

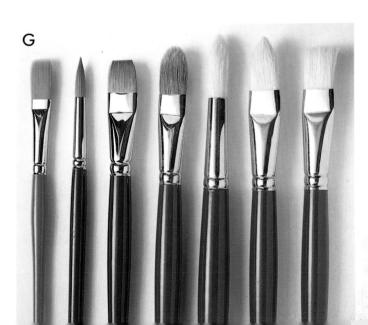

G

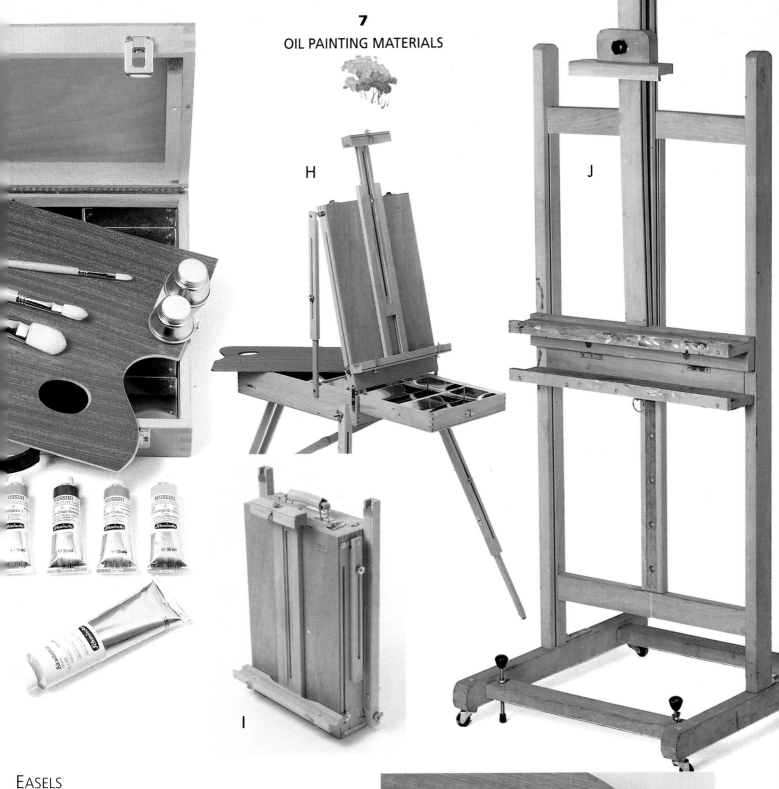

EASELS

There is an ample selection of easels to choose from: the typical outdoor easel is a wooden tripod that can be folded up for transportation; the French-style easel is used by most professional artists for painting in comfort outdoors (H), and folds up for easy transportation (I); the studio easel, especially designed for painting in the studio, allows the artist to paint large canvases (J).

PALETTES

There are different types and sizes of palettes. We recommend that you use a rectangular one that can be easily packed into your box. The three kinds you can see here (K) are the rounded wood, ideal for the studio; the white plastic one, easy to clean; and the rectangular wooden palette, which we recommended above.

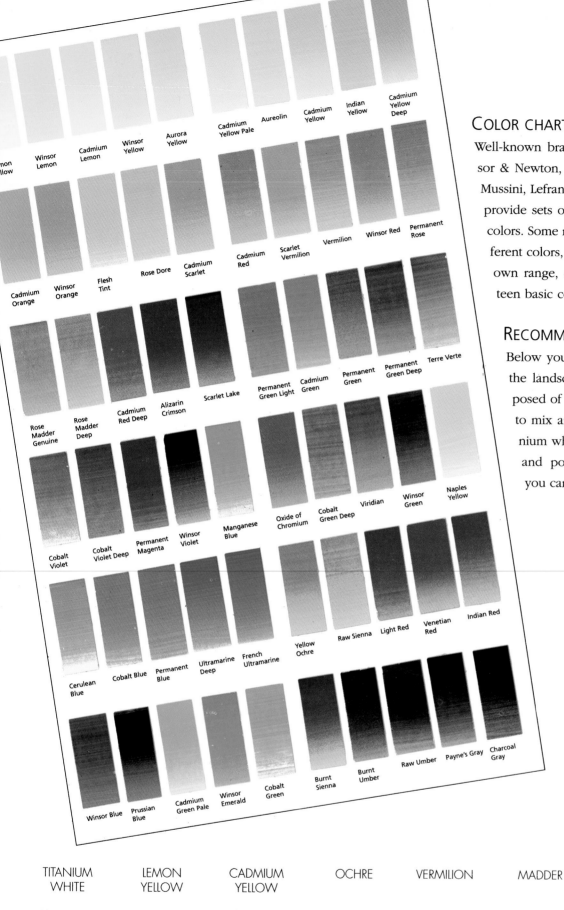

Lemon Yellow · Winsor Lemon · Cadmium Lemon · Winsor Yellow · Aurora Yellow · Cadmium Yellow Pale · Aureolin · Cadmium Yellow · Indian Yellow · Cadmium Yellow Deep

Cadmium Orange · Winsor Orange · Flesh Tint · Rose Dore · Cadmium Scarlet · Cadmium Red · Scarlet Vermilion · Vermilion · Winsor Red · Permanent Rose

Rose Madder Genuine · Rose Madder Deep · Cadmium Red Deep · Alizarin Crimson · Scarlet Lake · Permanent Green Light · Cadmium Green · Permanent Green · Permanent Green Deep · Terre Verte

Cobalt Violet · Cobalt Violet Deep · Permanent Magenta · Winsor Violet · Manganese Blue · Oxide of Chromium · Cobalt Green Deep · Viridian · Winsor Green · Naples Yellow

Cerulean Blue · Cobalt Blue · Permanent Blue · Ultramarine Deep · French Ultramarine · Yellow Ochre · Raw Sienna · Light Red · Venetian Red · Indian Red

Winsor Blue · Prussian Blue · Cadmium Green Pale · Winsor Emerald · Cobalt Green · Burnt Sienna · Burnt Umber · Raw Umber · Payne's Gray · Charcoal Gray

COLOR CHARTS

Well-known brands, like Talens Rembrandt, Winsor & Newton, Holbein, Grumbacher, Schmincke Mussini, Lefranc & Bourgeois, Daler-Rowner, etc., provide sets of an extraordinarily wide range of colors. Some manufacturers use up to ninety different colors, although each artist has his or her own range, consisting of not more than fourteen basic colors.

RECOMMENDED COLORS

Below you can see the colors used to paint the landscapes in this book: a range composed of twelve colors that easily allows us to mix and create any tone we wish. Titanium white is fundamental, since it covers and possesses great toning powers. As you can see, we have not included black.

THE COMPOSITION OF OIL PAINTS

Manufactured oil colors, although mass-produced, basically consist of a mixture of pure pigment with a small amount of linseed oil, as well as other additives such as wax. The ingredients must be carefully mixed or blended in order to obtain a totally uniform consistency. The paint is then packed in tubes made of aluminum.

TITANIUM WHITE · LEMON YELLOW · CADMIUM YELLOW · OCHRE · VERMILION · MADDER · TURQUOISE BLUE · ULTRAMARINE DEEP

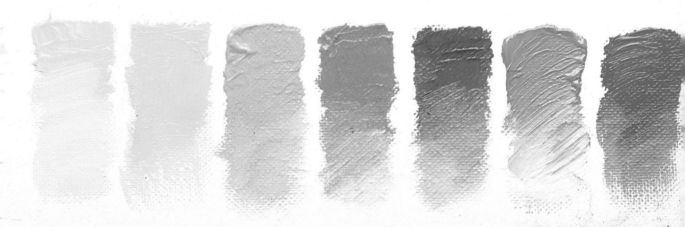

SUPPORTS USED FOR OIL PAINTING

The most commonly used support for oil painting is canvas or linen or cotton cloth mounted onto a frame or stretcher. There are, however, smaller formats on cardboard for small sketches and notes. The canvas or linen mediums are primed with a layer of glue, casein, or gesso, which allows the color to adhere without being absorbed.

On the right you can see some examples of these supports: linen on cardboard (A), canvas mounted on a stretcher (B), linen with a gray priming (C), and unprimed linen if you wish to do the priming yourself (D). There is also a stretcher carrier that allows two freshly painted canvases to be carried. The canvas is mounted on the frame with staples, and wedges are inserted inside the corners of the frame to stretch the canvas even tighter.

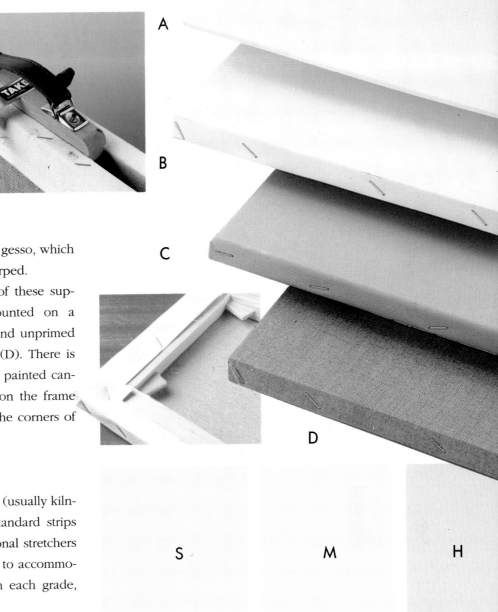

STRETCHERS

Stretchers in the United States are sold in strips (usually kiln-dried pine) that must be pieced together. Standard strips measure about 1⅜" wide by ¾" deep. Professional stretchers are offered in medium and heavy duty grades to accommodate larger works. For the lengths offered in each grade, refer to the chart on the right.

VIOLET CADMIUM GREEN EMERALD RAW UMBER

STRETCHER SIZES
(in inches)

STANDARD		MEDIUM DUTY		HEAVY DUTY	
8	26	8	28	18	62
9	27	9	30	20	64
10	28	10	32	24	66
11	29	11	34	30	68
12	30	12	36	32	70
13	31	14	38	36	72
14	32	16	40	40	74
15	33	18	42	42	76
16	34	20	44	48	78
17	35	22	46	50	80
18	36	24	48	52	82
19	38	26		54	84
20	40			56	86
21	42			58	88
22	44			60	90
23	46				
24	48				
25					

OIL PAINTING TECHNIQUES

*O*f all the pictorial mediums, oil is the most versatile. It allows you to touch up, correct, apply impastos...in fact, you can do practically anything you want or need with it. You can even paint over an already-painted canvas. In this chapter, we will give you some useful tips and let you in on some of the "secrets" of successful painting that will enable you to start off on the right track. Later your own experience will teach you what methods and techniques are most suitable for your way of working.

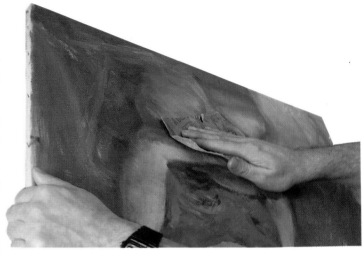

HOW TO RECONDITION A CANVAS

It is probable that, when you first start painting in oil, you will accumulate many canvases that are not worth saving. Here we will show you how to recondition a canvas. A simple way is to take advantage of the leftovers of paint on your palette and cover the canvas you wish to use again. This technique is used by many artists who do not want to start on a white canvas.

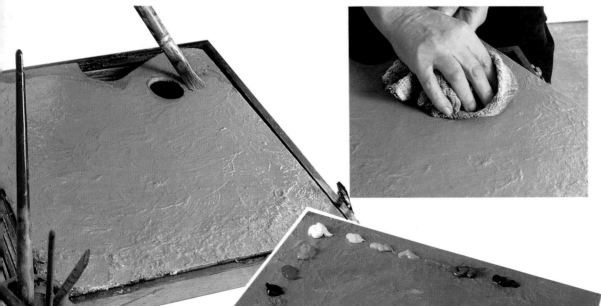

HOW TO REMOVE HEAVY LAYERS OF OIL PAINT

It is normal for oil paint to be built up into thick layers, which have to be removed before you can obtain a totally smooth surface. Use fine sandpaper or something similar to get rid of them, but use it with care to avoid damaging the canvas.

DON'T USE TOO MUCH WHITE

Look at the differences between these two illustrations that show the same color mixed with white (A) and with turpentine (B). In the first one, the paint loses its transparency and becomes lifeless; for this reason white should be employed very sparingly. Compare this example with the mixture of emerald green blended with yellow shown below. Note how, by mixing the two colors, brilliance and luminosity are created.

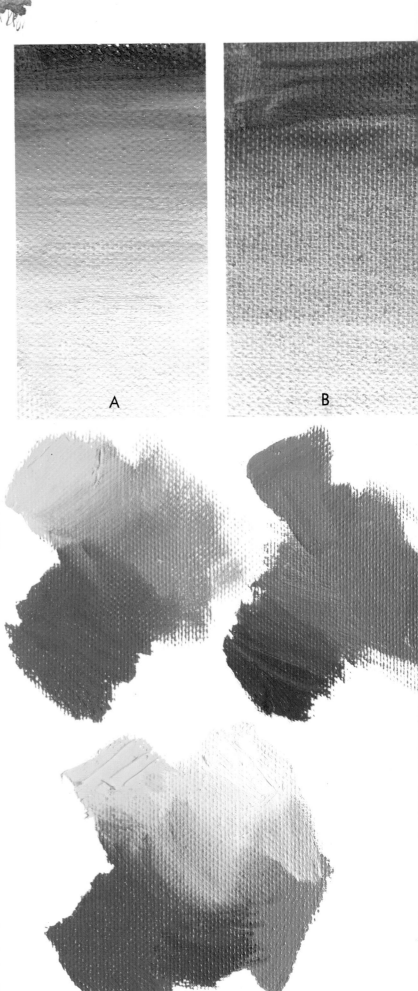

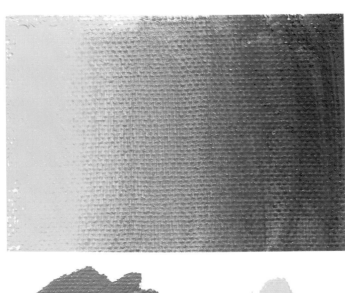

MIXING COLORS

To get to know the tricks of the trade, you must practice mixing colors. Look how we get green by blending blue and yellow together, and orange by mixing carmine with yellow. If you use the three primary colors—that is, carmine, blue, and yellow—you can obtain a rich and subtle range of broken colors that, when blended with white, exactly as you can see in the adjoining images, turns them into warmer tones, broken down by the influence of the predominating red and blue.

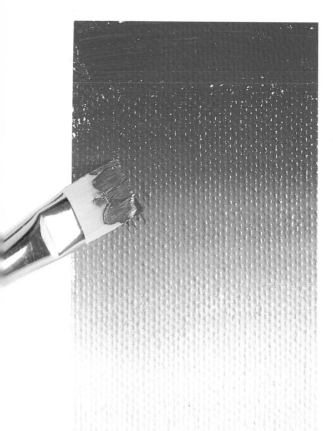

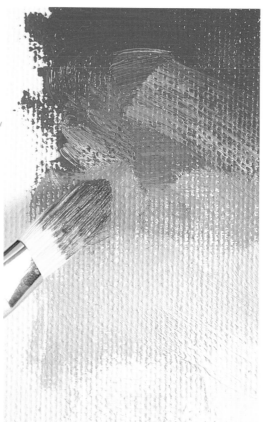

THE GRADATION TECHNIQUE

Technically speaking, there are many ways of gradating color. We will show you two of the best ways. On the left, the gradation of blue into white is done without showing any brushstrokes. This should be done using a fine hair flat brush, which enables you to carry out perfect sweeps of color. On the right, a hog-bristle brush is used to create an impressionistic gradation in which both colors are blended with clear brushstrokes.

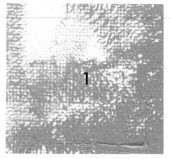

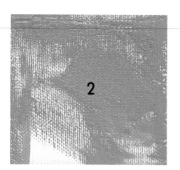

THE TEXTURE OF CANVAS

Not all canvas surfaces are alike. Depending on the thickness of the material, the texture can vary greatly. Note the difference in texture after applying some green paint on these two different types of canvas: one made of cotton (1) and the other of linen (2).

COLOR IMPASTOS

Below are two images in which we have applied accents of orange on a still-fresh background. The difference between the paint applied with a brush and that applied with a palette knife can be seen clearly. In the first case the sharpness of color is relative, since the brushstroke mixes the two colors in certain areas. In the second, a clean and voluminous orange is obtained by using a palette knife to apply the paint.

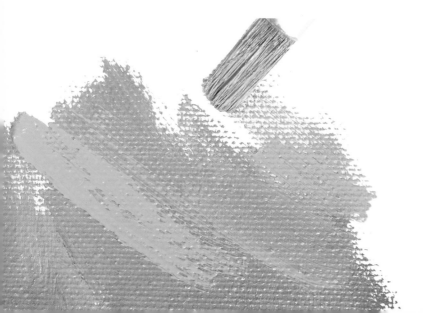

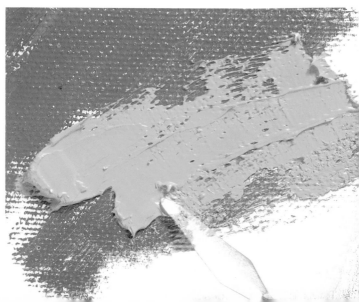

BLENDING COLORS WITH YOUR FINGERS

To obtain a good subtle blend, you can use the tip of one of your fingers, making delicate rounded movements, a technique more commonly used in portraits than in landscapes. Nonetheless, there are times when the artist uses this technique to soften a hard line, especially when painting clouds.

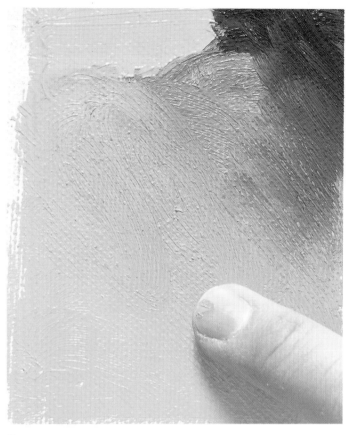

REMOVING COLOR

If you wish to remove a color, use a rag or something similar that is sufficiently dampened with turpentine; this way you will remove the color and recoup the color of the canvas. Obviously this technique should be carried out when the paint is still wet.

SGRAFFITOS IN OIL

If you want to obtain a sgraffito effect—that is, bring out the base color by scratching off the paint on top—the paint has to be applied in layers. In the image below you can see how, by using the handle of the brush, we have made some incisions in green painted over gold, thus revealing the latter. To achieve this effect, the green had to be applied after the gold paint was dry.

PAINTING ALLA PRIMA

Using a round, fine hair brush—preferably made of sable—apply some paint over a damp area without pressing too hard. Quickly clean the brush and go over it again—without pressing—or use a clean rag, making sure not to mix one color with another.

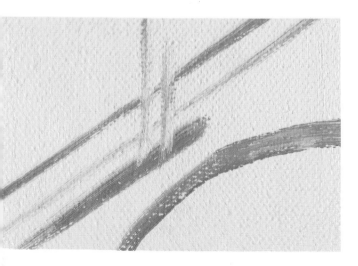

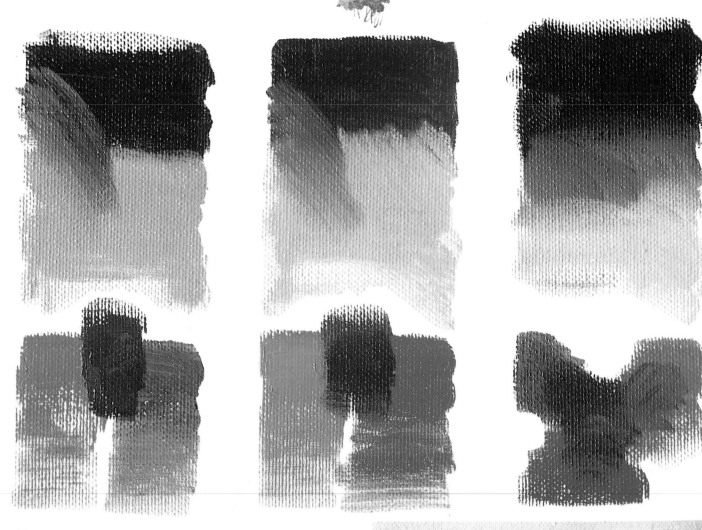

HOW TO MIX BLACK

A mixture of carmine and emerald green will result in a black hue, as you can see above. When it is lightened with white, it has a certain luminosity, determined by the composition of colors we have used. The same occurs with the other mixtures: carmine and ultramarine produce a black with a violet tendency. Last, the most neutral black is made up of ultramarine deep, carmine, and emerald green. These results show beyond a doubt that there is no need to use the color black.

PAINTING WITH ONE, TWO, OR THREE COLORS AND WHITE

To familiarize yourself with brush techniques and understand how to mix colors to obtain different hues without having to buy a complete color range, we recommend that you practice the following exercises. We have painted three identical landscapes. The first has been painted with only raw umber and white, for a monochromatic value study.

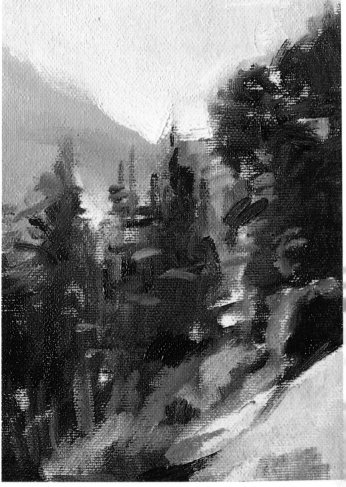

The second is a two-tone image, using raw umber and ultramarine blue. By combining both colors and blending them, in distinct proportions, with white, we give the picture a great wealth of color: blue hues for the sky and the mountains of the background, and the rest in raw umber. By mixing the colors together, we obtain a dark value of a neutral color that enables us to paint the trees and shadows for volume. In the third example, using three basic colors—carmine, blue, and yellow, plus white—we can mix practically every color.

This kind of exercise is essential for a sound understanding of color composition; furthermore, you learn how to mix color. When you have mastered this technique, you will see how easily you yourself can control the tonality of a color according to your needs and tastes.

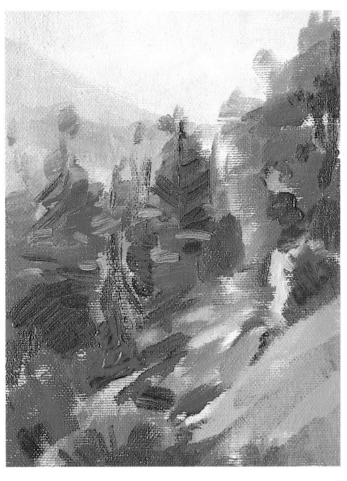

ON THE USE OF BLACK

Remember that the color black available in stores has no luminosity, even when it is mixed with white. Furthermore, it is not advisable to mix black with other colors because it dirties them. In reality there is no need to use black: light is present in nature even in its darkest form. There are enough combinations in the color range that can be substituted for black.

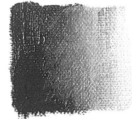

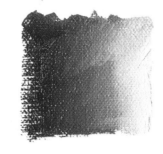

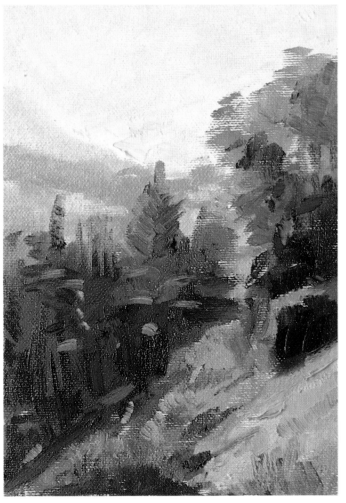

PAINTING A LANDSCAPE OF FIELDS

*I*t is difficult to establish a relationship between easy and complex exercises in landscape oil painting, since the very word landscape conjures up a wide range of themes: skies, trees, mountains and an almost endless list of elements and details whose complexity depends on the painter's mastery of synthesis. For this reason we have chosen an extensive range of landscape subjects with different kinds of compositions that will enable you to learn the technical aspects in a step by step form.

MATERIALS

- Gray canvas mounted on a stretcher (18" × 12")
- Stick of charcoal for drawing
- Flat hog-bristle brush number 14
- Round hog-bristle brush number 8
- Flat synthetic brush number 14 and ordinary oil palette 12" × 16".
- Oil colors: titanium white, yellow medium, yellow ochre, English red, vermilion, madder, cobalt violet, turquoise blue, ultramarine blue deep, cadmium green, emerald green, raw umber

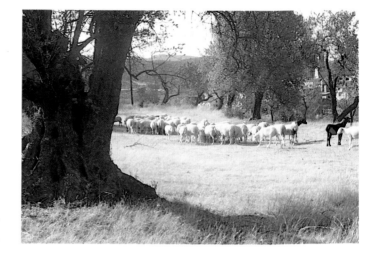

1 To start we recommend a classic theme with a limited palette of mostly neutral colors: a tree in the left foreground and the horizon camouflaged by elements in the middle ground that divide the composition into two parts. The most important lesson of this exercise will be how to use the brush to obtain a loose but confident effect.

2 We begin our picture by marking out the basic composition of the theme with a piece of charcoal. It is not necessary to draw a detailed sketch, since you will later cover the sketch lines on the canvas with paint. For instance, instead of depicting the sheep, we merely indicate them in relation to the other elements that make up the landscape.

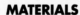

1

2

The effect of light on grass can be achieved by blending white, ochre, and yellow; the rasping character of the brushstroke produces an ideal effect in such cases.

The darkness of the trunk was achieved by mixing together pure colors such as madder, ultramarine, and raw umber.

The base color of the central treetop is cadmium green, toned with emerald, white, and a touch of cobalt violet.

The hues of the houses that can be seen through the branches are a series of grays obtained from a mixture of emerald, violet, and white.

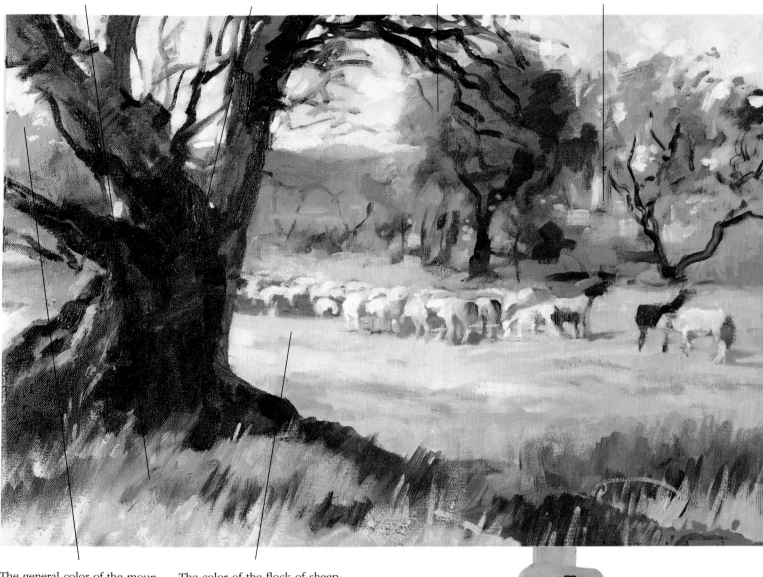

The general color of the mountains in the background has been created by mixing ultramarine, white, emerald green, and direct touches of turquoise.

The color of the flock of sheep is a mixture of raw umber, ocher, and white. The different hues that can be seen were mixed by using almost equal amounts of each one of these colors.

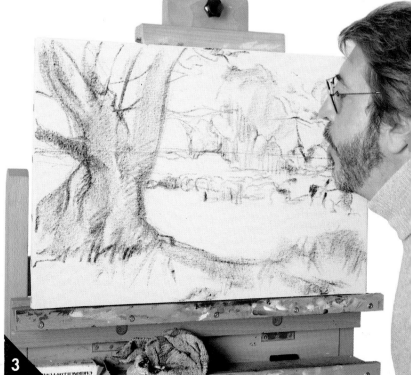

3 Once the charcoal drawing is finished, remove the charcoal dust that will have accumulated on the canvas so that it doesn't dirty your strokes of color. One of the most common ways of doing this is to blow over the drawing, just as you can see in the adjoining photograph.

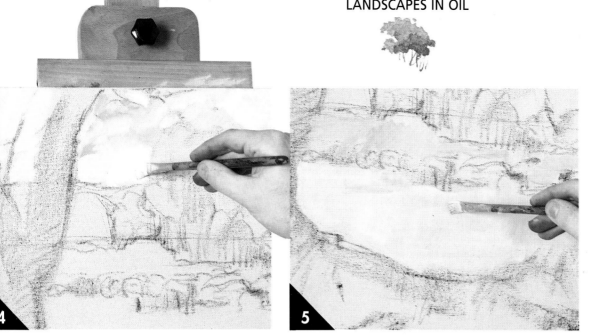

5 We take advantage of the blend of colors used in the sky for the strokes that make up the center of the field by adding a little ochre to obtain that golden appearance. Modifying this tone with a dab of raw umber, we vary the hue to keep it from becoming too monochromatic.

6 We now start painting the mountains that appear in the distance. Because it is in the farthermost part of the background, we use a bluish-gray tone from a mix of white, ultramarine deep, and a touch of raw umber to break the blue and thus achieve depth.

4 Since we are using a gray-toned canvas, we can start on the sky. We use a bright range of whites, lightly toned with turquoise blue in the upper area. We work toward the center with warmer tones.

7 To establish the colors and values of the whole in order to complete the first stage of the picture, we work with a certain looseness, moving quickly from one area of the picture to another. For the foliage of the background, we use a range of greens, mixing permanent green toned with raw umber in the darker areas and ultramarine in the remaining parts.

8 We continue to work on the painting as a whole. The colors have been toned and harmonized to create an intervening atmosphere that allows us to go on to the darker values we will paint in the foreground. Through this first stage we have used just one brush, a number 14 flat hog-bristle brush.

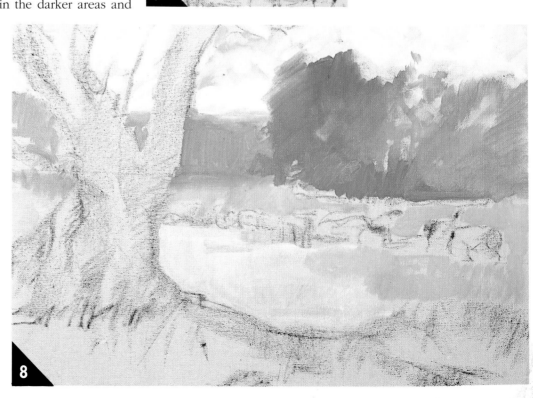

9 The first strokes of color that correspond to the shadow cast on the ground by the tree are also used to begin to suggest the shrubs in the foreground. To do this we use some raw umber mixed with yellow ochre.

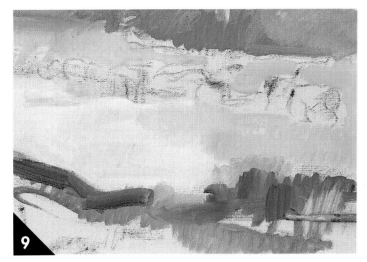

11 Using the same blend of ultramarine and madder, we add volume to the trees in the center. Here the color is less intense than before, since it has been blended with the green background hue with the brush.

10 The blend of ultramarine with a touch of madder provides us with the ideal tone for defining the shape of the tree; the mixture of dark colors on our palette allows us to avoid using black.

12 In the second stage, the different planes and colors have been established. We will leave it for a while so that the next brushstrokes do not get too mixed up with the previous ones.

13 Using a rounded number 8 brush—that is, finer than the one we were using before—we get down to the final touches, starting with the brushstrokes corresponding to the shadows of the sheep, alternating between English red and a grayish tone for the shadow.

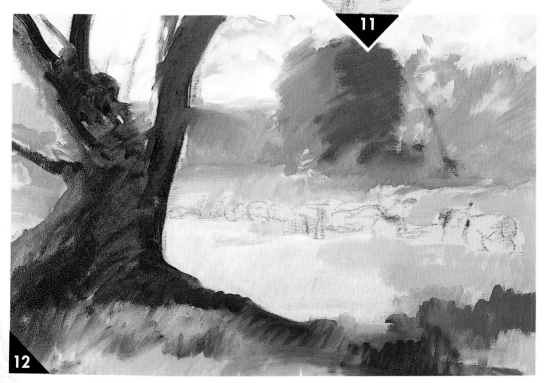

14 With a very pure color, and without mixing it with turpentine, we paint the tree trunks in a dark tone obtained from a blend of ultramarine and carmine. If you look at your palette, you will see that the mixtures you have made up provide you with a good color range that you can take advantage of.

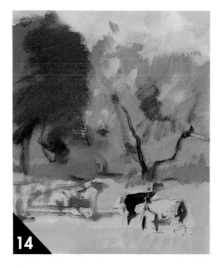

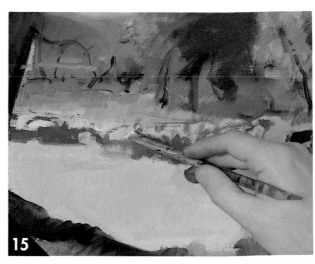

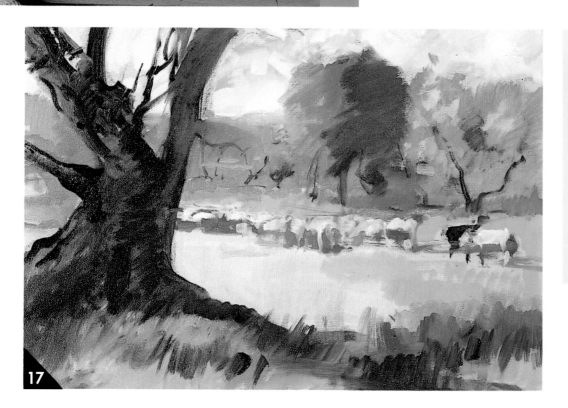

15 We again return to the sheep, this time to fill in the spaces of light, using tones harmonized with a touch of ochre. We apply the strokes with a flat synthetic brush to obtain clean color interaction without smearing the color of the contour.

16 We use a half-dry hog-bristle brush to "drag" the still-wet color of the tree's shadow to obtain the effect of scrub.

17 Note the appearance of the third stage of the picture, in which the rich color has become an important part of the composition: the hues used to paint the central foliage and the surrounding ground, with violet tones that harmonize with the greens, and the very clean greens contrasting with the ochres; similarly, the violets and different earth colors used for parts of the tree are slightly highlighted.

DILUTING OIL

It is advisable to carry out the first applications of oil paint with the paint half-diluted with turpentine. This helps the first stage to dry, thus enabling you to keep later applications of thicker paint clean and pure. This also ensures that your painting will not crack with the passing of time.

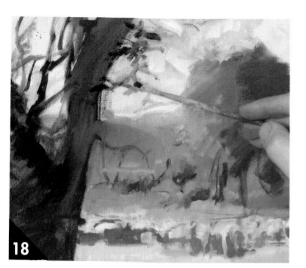

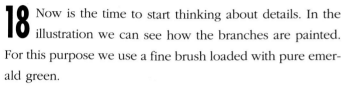

19 Seeking out the light, just as the Impressionists did, we create a color interaction by painting yellow over the violet background tone since this is violet's complementary color. These effects make the colors vibrate and add luminosity.

18 Now is the time to start thinking about details. In the illustration we can see how the branches are painted. For this purpose we use a fine brush loaded with pure emerald green.

20 Given the impressionist nature of this work, our brush strokes are used to suggest rather than to paint details. Note the impact of the white paint that we have used to depict the houses of the background.

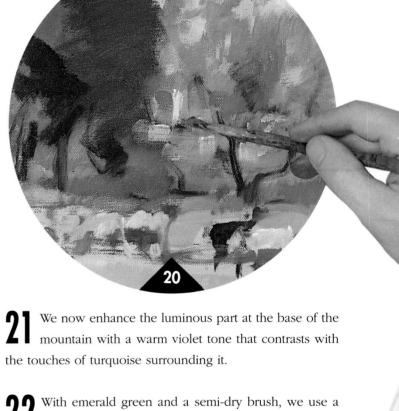

21 We now enhance the luminous part at the base of the mountain with a warm violet tone that contrasts with the touches of turquoise surrounding it.

22 With emerald green and a semi-dry brush, we use a dry brush technique to take advantage of the texture of the canvas and to paint the foliage in a direct and spontaneous manner.

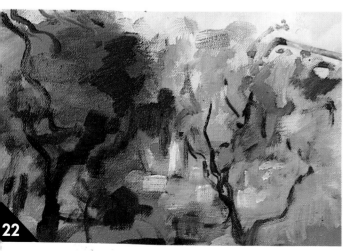

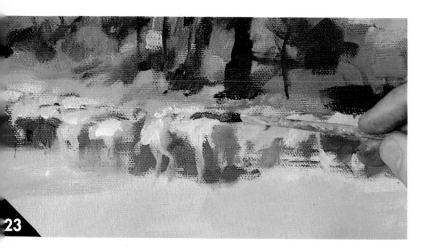

23 Gradually we add form to the flock of sheep. See in the illustration how we define the form of the sheep of the foreground and the volume of the others; to do this we use a grayish tone applied with a fine brush.

24 This time we apply some pure white in the upper area of the sheep to create the effect of the light they receive from above. To obtain clean brushstrokes, we must apply them to the canvas without scraping or dragging them.

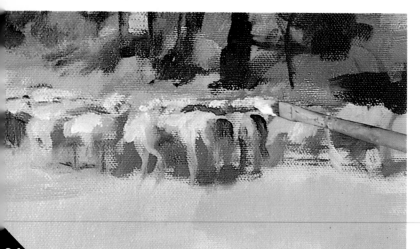

CLEANING THE PALETTE

Although we said that you should take advantage of all the color on your palette, you will get to a point when there is no remaining space for mixing hues. The best way to clean the palette is with a rag.

25 In order to add texture and interest to the area of land between the shadow of the tree and the sheep, we paint a few horizontal colored lines with a beige tone, obtained from a blend of raw umber, ochre, and white.

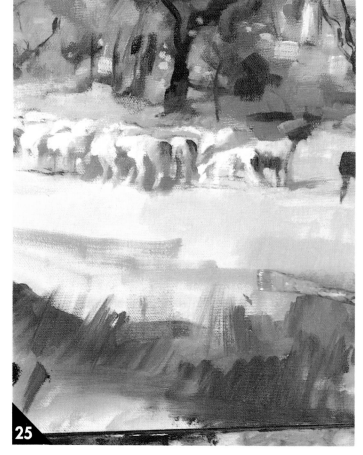

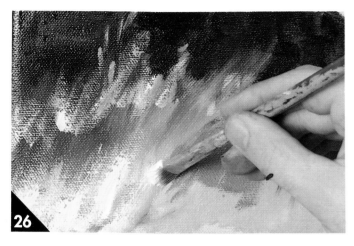

26 Coming to the end of this picture, we carry out a series of final touches. Here in the illustration, several sweeps of ochre, yellow, and white create the effect of sunlight on the scrub at the foot of the tree.

27 The only thing remaining is to show you the completed work in which, from the very start, we have attempted to emphasize the spontaneity and the impressionistic character of the painting.

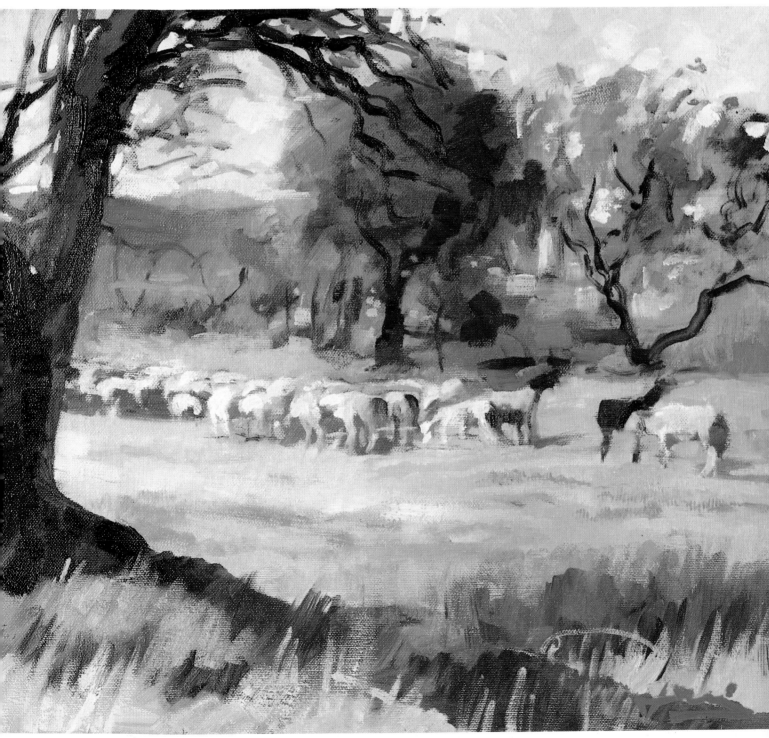

PAINTING A SNOW-COVERED LANDSCAPE

*T*his time we are going to attempt this spectacular snow-covered landscape. It is a fine sunny day with several clouds shrouding the mountain peaks producing an extraordinarily beautiful view. This scene is good seen from any point of view; nonetheless, I have chosen a composition in which a tree takes up the foreground. Since light and shadows change with the passing of the day, I have decided to paint it in one single session.

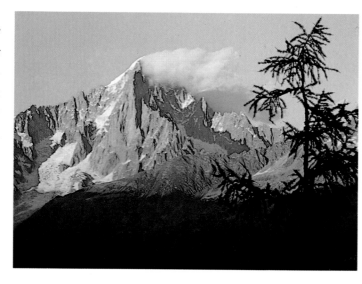

MATERIALS
- White canvas mounted on stretchers (24" × 18")
- Charcoal
- Brushes: flat synthetic number 12 and a flat hog-bristle brush number 16
- Colors: titanium white, cadmium yellow, cadmium orange, ochre, vermilion, madder, raw umber, cobalt violet, turquoise blue, emerald green, ultramarine
- Rectified turpentine and a fast-drying medium

1 Whenever you find a scene worth painting, look for several interesting points of view and draw a few sketches. For this reason it is essential always to have a drawing pad and a few wax crayons with you.

2 We draw the general outlines of the theme, with an ordinary piece of charcoal. Don't try to bring out too much detail for the time being. Remember, also, that the dimensions of a landscape are not as important as they are with other subject matter.

The sky has been painted with ultramarine and turquoise blue mixed with white, using direct brushstrokes. The two hues have slight variations in intensity.

The main color of the mountain is obtained by mixing ochre, raw umber, and white. The brightly illuminated areas have been painted with white, and the darkest areas have been painted with raw umber.

The blue hues used for the areas of the mountain in shadow are the result of some cobalt violet and ultramarine mixed with white.

The tree has been painted with emerald green and cobalt violet without any mixing.

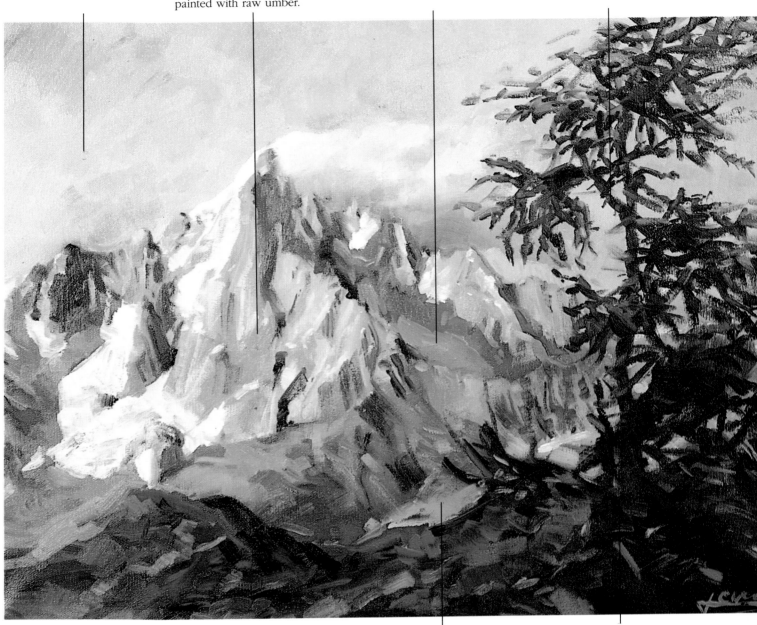

At the base of the mountain there are various hues of ochre mixed with raw umber and violet. The most striking and luminous touches of color were painted with pure orange.

The dominant part of the foreground has been painted with alternate cool and dark colors, mixtures of emerald green and carmine, and of violet and raw umber, plus several strokes of pure ultramarine light.

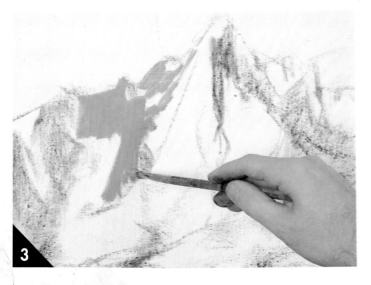

3 We begin by determining the color and value of the mountain, a slightly broken golden tone, which we obtain from a mixture of ochre, some raw umber, and a touch of white to tone it. We apply the paint with a flat number 12 synthetic brush, which we will use for practically all the first brushstrokes.

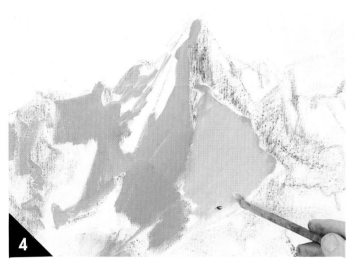

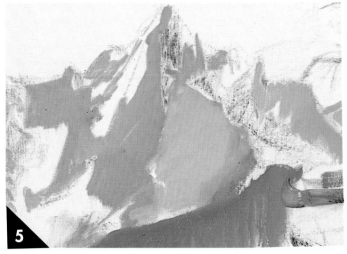

4 We have to paint quickly. Remember that the color choices result from an interpretation of the scene we are observing. Try to make the brushstrokes correspond to the forms that we observe in nature.

5 We darken the color with carmine and start on the middle ground, corresponding to the foot of the mountain. During this phase the color is diluted with turpentine with a small amount of fast-drying medium added to enable it to dry more rapidly.

7 We continue to develop the color in the landscape, going from one side of the canvas to the other. This time we have added some carmine to the blue to obtain the violet tone that you see. During this first phase, we paint with flat tones and simplify the whole.

6 Now we begin to vary the color, looking for the shadows that give form and volume to the mountain, confidently applying ultramarine with white, bringing out the form, and giving the brushstrokes character.

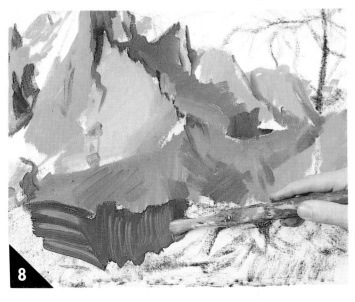

8 The new grayish tones with a hint of violet—obtained by mixing up the remains of ochre and blue with cobalt violet—are applied in the foreground, where there are large areas in shadow.

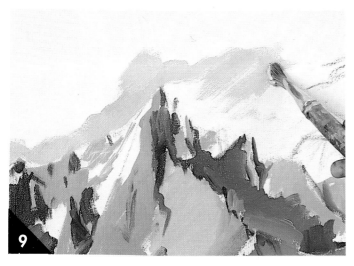

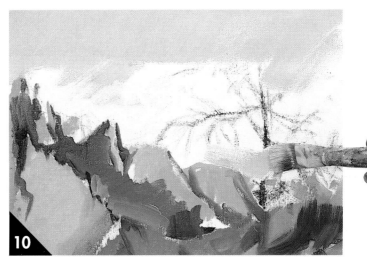

9 Once the first general color and value of the mountain and the foreground have been applied, we clean the palette to make way for the colors we will use in the sky. We start out by mixing ultramarine with white.

10 Using the tip of the brush, we apply several curved strokes of turquoise blue to fill in the sky. The adjoining photograph shows the moment when the lower right-hand part of the sky is being painted while reserving the part corresponding to the clouds for some different tones.

CLEANING THE BRUSHES AND PALETTE

Whenever you need to use a color that clashes with the others on your palette, clean your brushes with turpentine and dry them with a rag. This way you avoid muddying the new tones. Also, clean the palette with a rag when it becomes so full that you have no space to mix new colors. Take advantage of this pause to analyze your work.

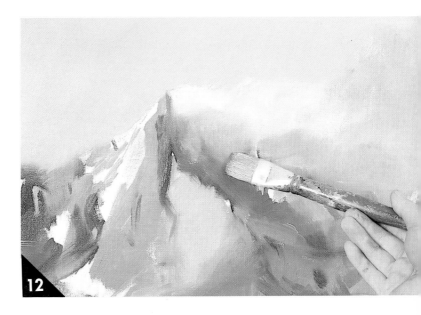

11 With a hog-bristle brush harder than the one we used before, we blend the clouds by rubbing, mixing the general color tone with that of the sky; the tone in question consists of white with a touch of raw umber added.

12 The tone of the mountain's shadow is blended with that of the cloud to define the volume of the cloud.

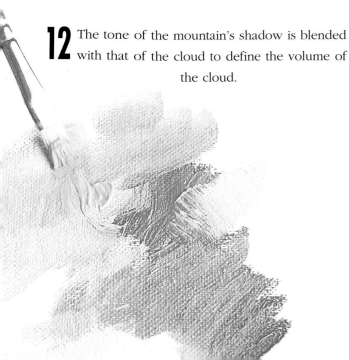

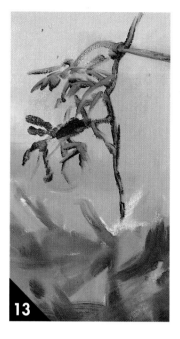

13 We now construct the foreground, in which the structure of the tree is a significant part of composition. We go about this task with a new synthetic brush that enables us to paint the tree without removing too much of the sky color, alternating between emerald green and dabs of pure violet.

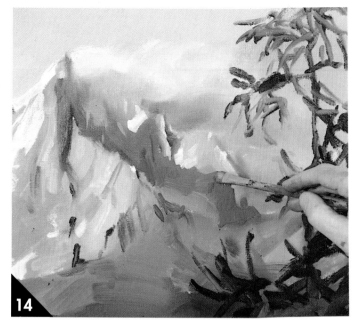

14 The toned cobalt violet darkens the mountain's shadow. This is perhaps the most delicate moment of the painting, since modifying the work does not mean redoing it. We have to continue constructing and harmonizing in a general and spontaneous way.

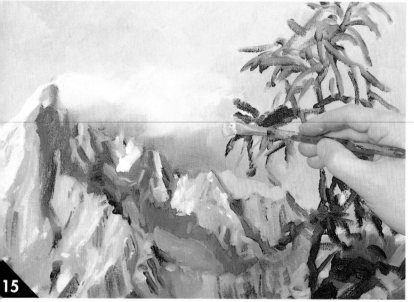

15 We continue filling in spaces and harmonizing, each time using a different tone; now we bring out the brightness of the cloud by darkening the branches of the trees with a mix of ultramarine blue and white.

16 Note that the mountain has a series of pure white areas depicting the brightest areas of snow. The same white is used to touch up the clouds to give them light and volume.

PAINTING THE WHOLE

It is important to take care when applying the first strokes of paint. At the same time it is essential to paint the composition as a whole without getting caught up in details; leave them until the end. Because hours tend to fly by when you are painting, you may have to finish the details in the studio. A good way to keep a reminder of the subject is to take some photographs of it.

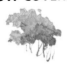

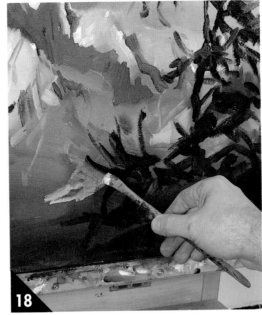

18 Now we are looking for the lighting effects at the base of the mountain. We apply yellow ochre in the most illuminated area and blend it with the background in contact with the branch. As you can see, the brushstrokes we are applying are always direct; this way we can obtain a loose effect.

17 We return to the branches, this time to finish painting them. Again we use a mixture of emerald green and cobalt violet to give the branches form.

20 With ultramarine, we reconstruct the mountain slopes. Applying loose but precise brushstrokes, we use this color to make the other warm tones vibrate.

21 To soften the shadow, we lighten some areas with violet mixed with white—the best tone for obtaining light and contrast.

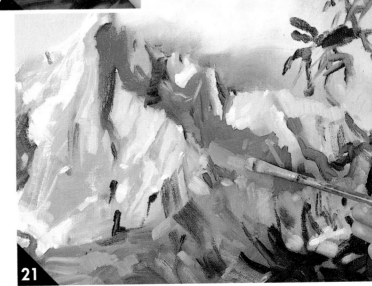

19 New touches of white add more light. Avoid excess detail that can make the painting appear dull and lifeless. Because the base color is still wet, these color highlights must be applied directly and boldly so that they do not mix with the color of the background.

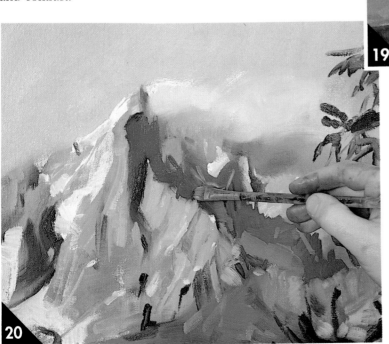

22 Using intermediate and general tones, we continue to build up the painting. The fast-drying action of the medium makes it possible to apply color on top without removing or damaging the previous layer. Here, we are painting with beige composed of a mixture of raw umber and a small amount of ochre and white.

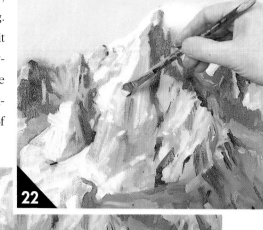

23 Using the same method as before, new light areas are opened up at the base of the mountain with direct strokes of golden tones. We pause, step back, and observe our work, comparing the picture to reality. Correct anything that is necessary, but try not to lose the spontaneous nature of the picture.

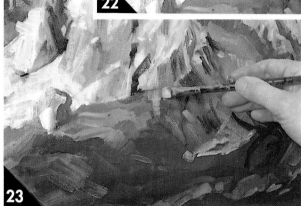

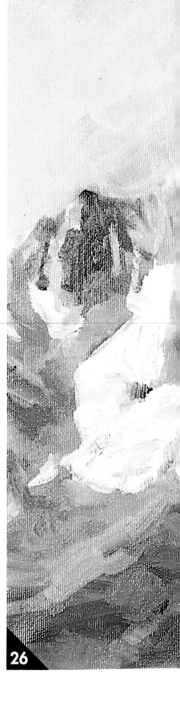

24 The foreground needs more contrast to bring it closer. Using the mixture of violet and raw umber, we create a sense of distance to indicate the middle ground.

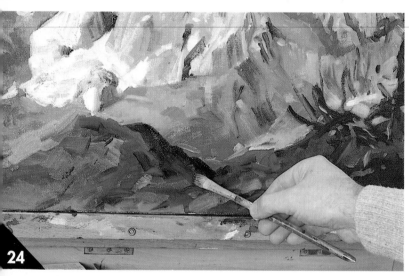

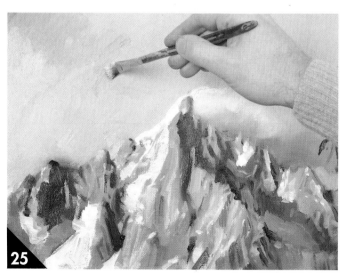

25 To finish, we highlight the sky, creating a wide range of blues to break up its uniformity of color. These final brushstrokes are of ultramarine mixed with white, creating a subtle contrast with the surrounding turquoise tones. This is the moment when we have to decide whether to continue or leave the painting. I have decided to leave it at this point.

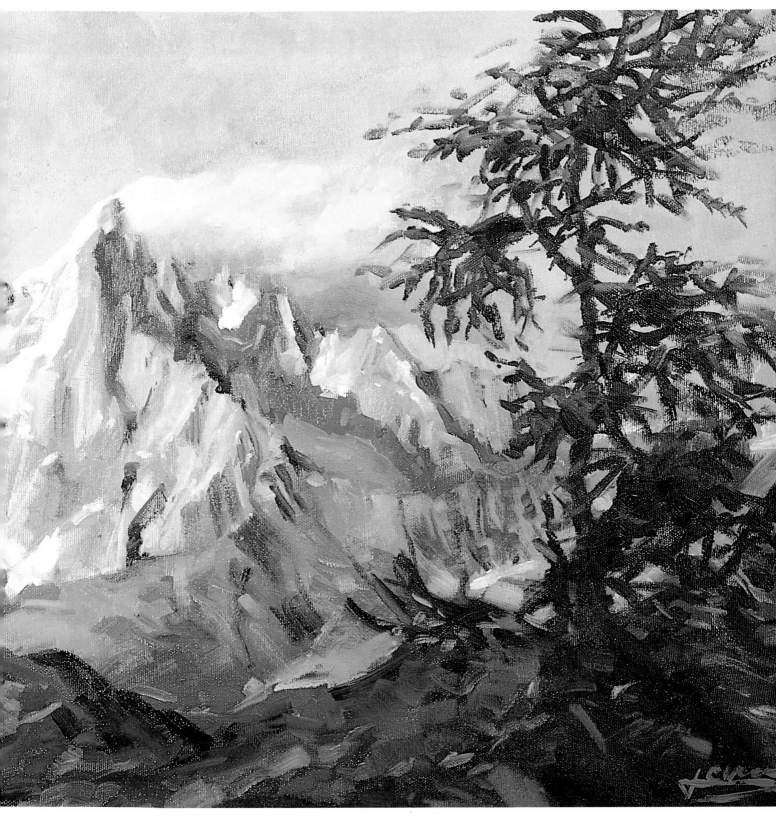

26 This is the finished painting. It has taken three hours to complete this landscape. The light now is considerably different from what it was when we began. Nonetheless, the resolution and speed with which the first strokes were applied provided an excellent reference concerning the lighting conditions.

PAINTING A VALLEY

There are two points to take into account in this valley: the perspective of the fields, which corresponds to the horizon line; and the predominant color, ranging from the different greens of the foreground to the blues of the background, which give the picture a feeling of distance and depth. Here we will see how we interpret color in such a way that the colors are slightly exaggerated when compared to reality.

MATERIALS

- White canvas mounted on stretchers (28" × 20")
- Charcoal
- Brushes: flat synthetic number 12, hog-bristle filbert number 14
- Colors: titanium white, lemon yellow, yellow ochre, vermilion, madder, burnt umber, turquoise blue, ultramarine light, permanent green, emerald green, cobalt violet
- French-style easel
- Rectified turpentine and dippers
- Rags and newspaper

The base tone of the upper part of the mountain is a mixture of ultramarine blue and cobalt violet; the lower areas were painted with the same mix but with some permanent green and white added to lighten the tone.

The different tones of the valley are a mixture of permanent green and white; the golden areas are the result of the same blend with some ochre added.

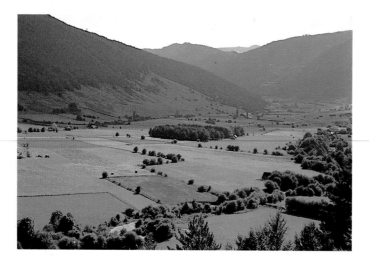

2 Using a mixture of ultramarine and a touch of carmine toned with white, we start to define the shape of the background with a number 14 hog-bristle brush. As always, at the beginning thin the color with turpentine.

The deep green that can be seen in the bottom of the foreground of the valley is a direct application of permanent green, slightly toned with lemon yellow.

1 Since the theme lacks any significant details, you can start the picture by drawing in the general lines of perspective.

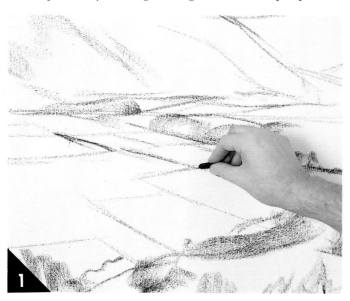

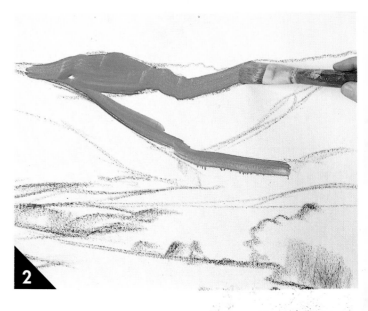

PAINTING A VALLEY

The golden field we see basically consists of ochre with a touch of emerald green in certain areas.

We painted the sky with a warm tone that contrasts with the blue of the mountains.

The value of the distant mountains was obtained by mixing ultramarine and cobalt violet, adding a quantity of white according to the darkness of the area.

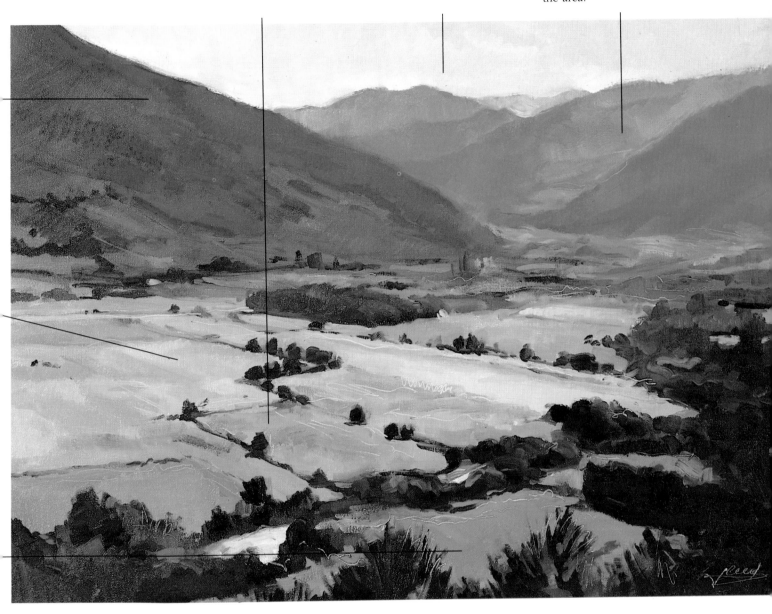

3 Using the previously mentioned mixture, fill in the mountains. The blue on the palette seems slightly lighter than it appears on canvas; this optical illusion is due to the palette's dark color, but the real color becomes apparent when the blue is applied to the white canvas.

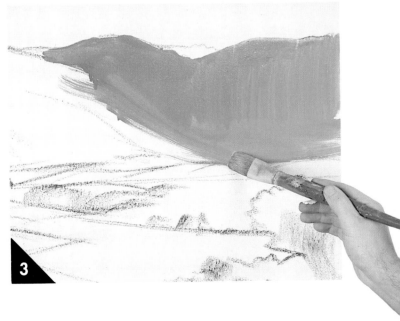

4 To differentiate between the different planes of the mountains, we darken the tones with ultramarine.

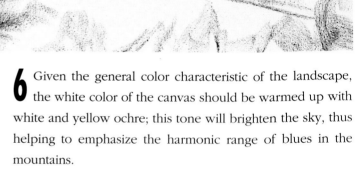

5 Even though this is still the first color laid down, we pause for a moment to take stock of the gradual increase in value and tone, the first step to a succession of planes.

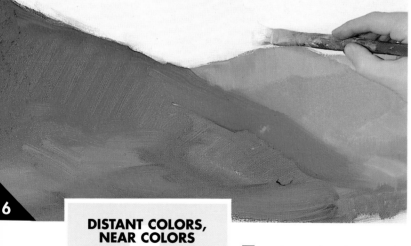

6 Given the general color characteristic of the landscape, the white color of the canvas should be warmed up with white and yellow ochre; this tone will brighten the sky, thus helping to emphasize the harmonic range of blues in the mountains.

DISTANT COLORS, NEAR COLORS

Cool colors—blues, violets, etc.—give us the feeling of distance. The more they are mixed with yellows or bright colors, the nearer they appear. To sum up, a color loses its intensity and acquires a bluish tone the farther away it is.

7 We begin the planes and fields that make up the valley using a warm range of greens. These colors are the result of the existing atmospheric light. The planes are accentuated with golden and luminous tones to make the background recede.

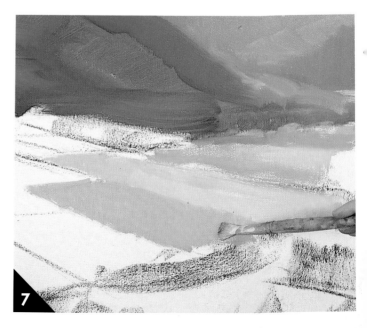

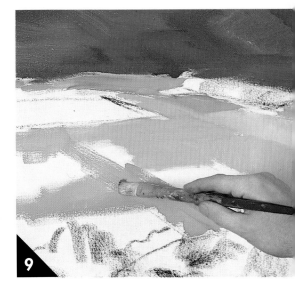

8 I paint in the general tone of the valley, distinguishing each field with a variation in color. A small amount of ochre has been added to the previous mixture to warm it up somewhat.

9 Now some permanent green is added to the mix to make a brighter tone for the first planes of the valley.

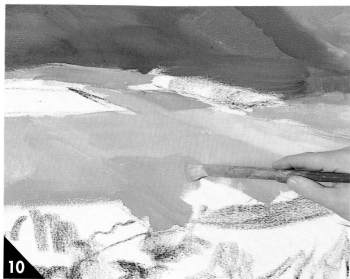

10 The general tone of each field depends on the kind of crops growing in it. In this case we have applied pure ochre.

11 In this second phase the general color of the valley floor has been established, and the background has now been given depth by the brightening of the tones in the foreground.

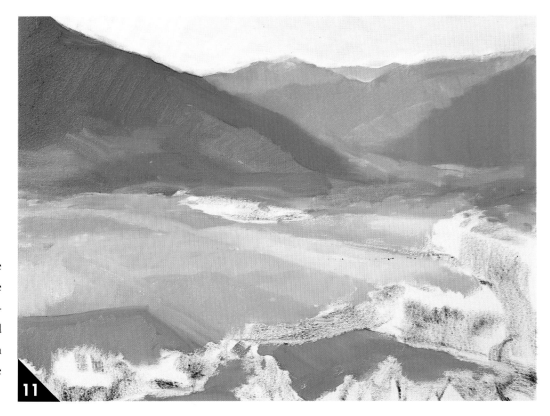

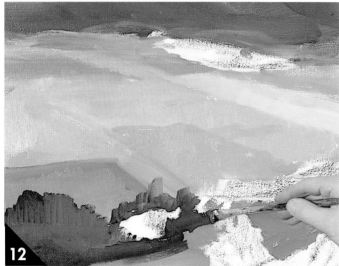

12 The simplicity of this composition makes it easier to paint the first brush strokes with a certain amount of immediacy; it is a matter of filling in the spaces with the tones according to our criteria. Here we have used a mix of pure cobalt violet and emerald green.

14 It is necessary to create a sense of distance between the wooded area and the foreground. To paint the woods on the right, we have used a green of a bluish tendency, obtained by mixing ultramarine, permanent green, and a touch of burnt umber.

15 Now that the first stage of the painting has been completed, it is important to compare it to the actual scene being painted. It is time to begin refining the color and values and developing the forms, working on everything at the same time without spending too much time on any one detail.

13 In a very direct and spontaneous manner, we define the shapes of the fields with a mix of permanent green and carmine to represent the trees and bushes dividing them.

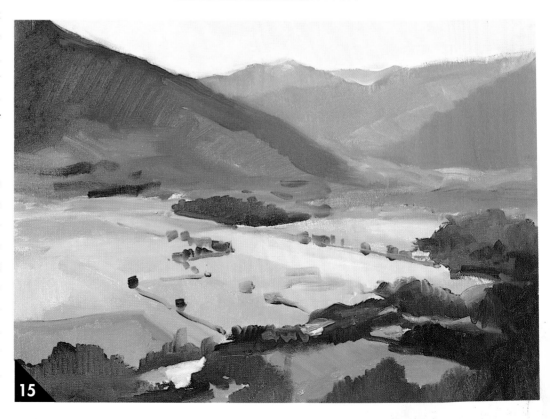

16 With a mix of violet, ochre, and white, I warm up the tone of the mountains very slightly to obtain an atmospheric effect. It is essential to let the brush just glide over the canvas without applying too much pressure on the brush. This enables you to add a light stroke of color that allows the base color to show through, giving the desired effect.

17 The hues of the end of the valley are painted with a direct brush stroke technique. We have used ultramarine and emerald green, making sure that each stroke has the same value as in reality.

18 New tones of a reddish hue are used to lighten the area where the valley meets the foot of the mountain. The variety of tones used depends on each painter's ability to interpret color.

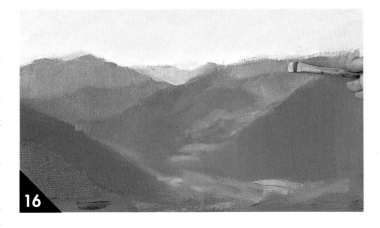

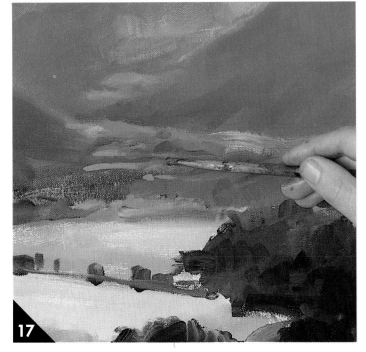

THE QUALITY OF A STROKE

The quality of a good oil painting is hardly ever determined by the care taken in including lots of detail. A good painter has to master the art of synthesis, which means that all detail should be conveyed through the artist's brushstrokes. This is no easy matter at the beginning, but if you take note of the methods and techniques we suggest in this book, little by little you will get there.

19 We return to the mixture of permanent green and violet, toned with white for the light planes at the foot of the mountain. Again, we suggest that you indicate the form by using light strokes of your brush.

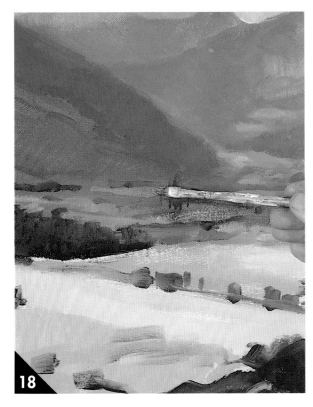

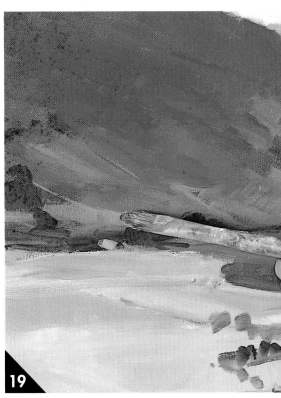

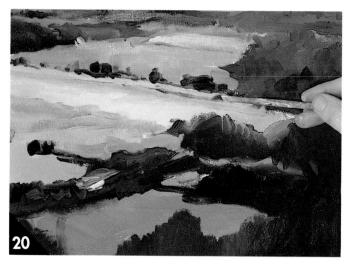

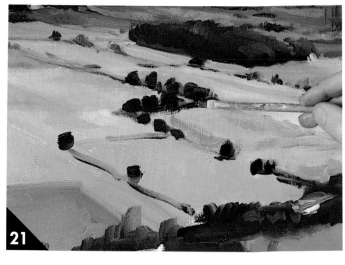

20 We are now ready to add the finishing touches. The flat colors are toned, and the work in general is harmonized. With a light gray added to the mix of white, umber, and violet, we paint the path that diagonally crosses the valley.

21 New touches of color give form and character to the trees in the center. We use emerald green directly over the previously applied violet tones. Detail does not have to be included—it should only be suggested by the additional strokes of color.

THE SGRAFFITO EFFECT

To obtain the sgraffito effect, the color base over which you work must be dry. Use the handle of a brush; don't use anything that is too sharp, or you may rip the canvas and cause irreparable damage.

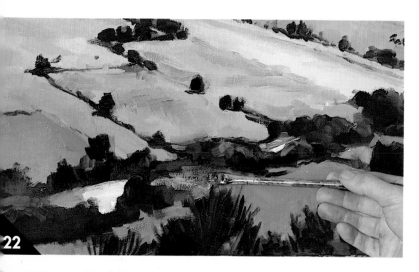

22 As the colors are refined, several variations of color are added to enrich the work; on this occasion I have slightly lightened the first planes with lemon yellow in order to give the work an accent of bright color.

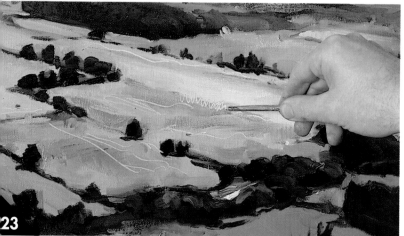

23 Taking advantage of the wetness of the picture, a few sgraffitos are added that provide the work with an original texture and help to distinguish the different fields; to achieve this effect, use the handle of a brush or similar object.

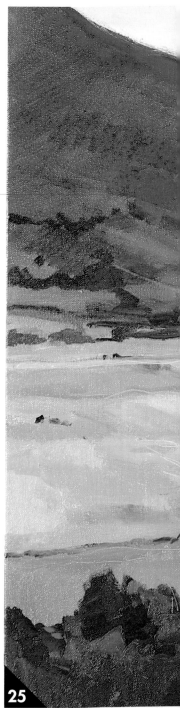

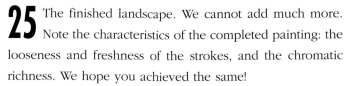

24 The final touches are applied with light touches of red and carmine over the trees of the foreground, taking care that the direction of the brushstrokes continues to define their form.

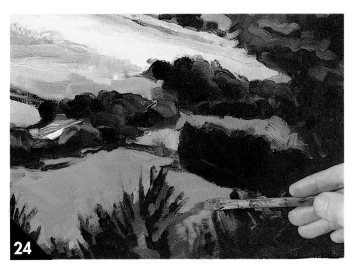

25 The finished landscape. We cannot add much more. Note the characteristics of the completed painting: the looseness and freshness of the strokes, and the chromatic richness. We hope you achieved the same!

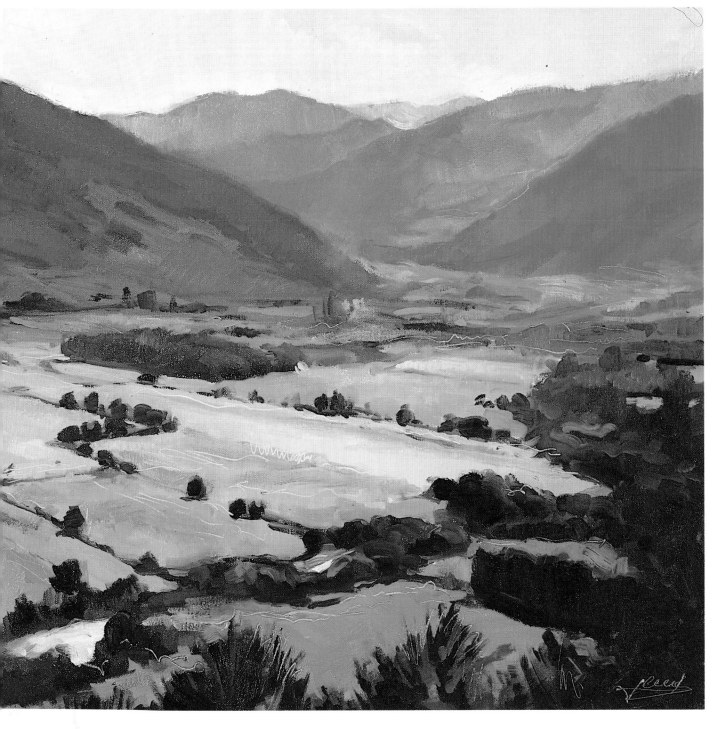

PAINTING AN ATMOSPHERIC LANDSCAPE

*T**he scene for this next picture is a hazy day in the countryside with a flock of sheep grazing in a field. The mist is thick enough for us to be able to blend it with the sky to such an extent that the sky will hardly be visible. The composition is horizontal and the predominant color goes very subtly from green to blue. The atmosphere of the theme makes this composition particularly attractive. Let's get down to work!*

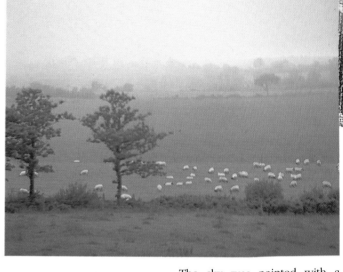

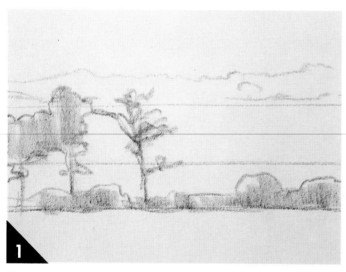

1 As in the previous paintings, the scene is drawn with charcoal; a few lines are enough to indicate the landscape. Searching out the best composition, we have situated a group of trees on the left-hand side of the canvas to break up the strong horizontal composition.

MATERIALS

- Gray canvas mounted on stretchers (28" × 22")
- Brushes: flat ox-hair brush number 14, flat hog-bristle brush number 10, flat synthetic brush number 12.
- Colors: titanium white, yellow medium, yellow ochre, vermilion, madder, raw umber, turquoise blue, ultramarine blue light, permanent green, emerald green, cobalt violet
- Palette and palette cups for outdoor use
- Rectified turpentine, drying medium, rags and newspaper

The sky was painted with a mixture of white, ultramarine, and a touch of ochre. This same tone, diluted with white and a dab of yellow, was used for the light areas.

The colorist mosaic of the most distant field is composed of emerald green and white lightly toned with raw umber. The upper light area was painted with the same mix but toned with white and cobalt violet.

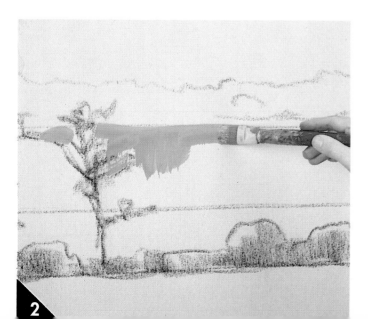

2 Now we fill in the largest spaces, starting with the central part, which coincides with the horizon line. We apply emerald green with a touch of raw umber and white—the color that will guide us throughout the rest of the picture—using a number 14 ox-hair brush.

The foreground is composed of a basic mixture of permanent green. The variations of tone seen in the grass were painted with touches of ochre, small curved bluish dabs, and a touch of sap green, mixed from emerald green and raw umber.

3 We go on to the back-ground pastures. This tone is brighter than the preceding one. The mixture used here consists of permanent green and white. Because these are the first strokes, the paint is diluted with turpentine, with some fast-drying medium added.

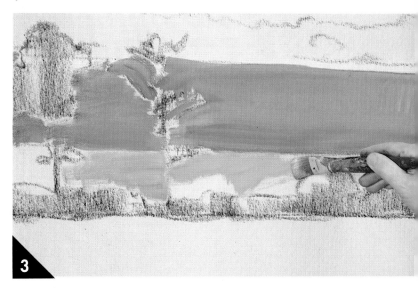

To create the atmospheric zone of the distant mountains, we have softened and blended the edges of the sky and the mountains.

There are various tones in the mountains of the background, but all were mixed from emerald green, white, and a touch of carmine toned with blue.

The general color of the bushes is a mixture of emerald green and raw umber; in the lighter areas, touches of permanent green mixed with ochre were used.

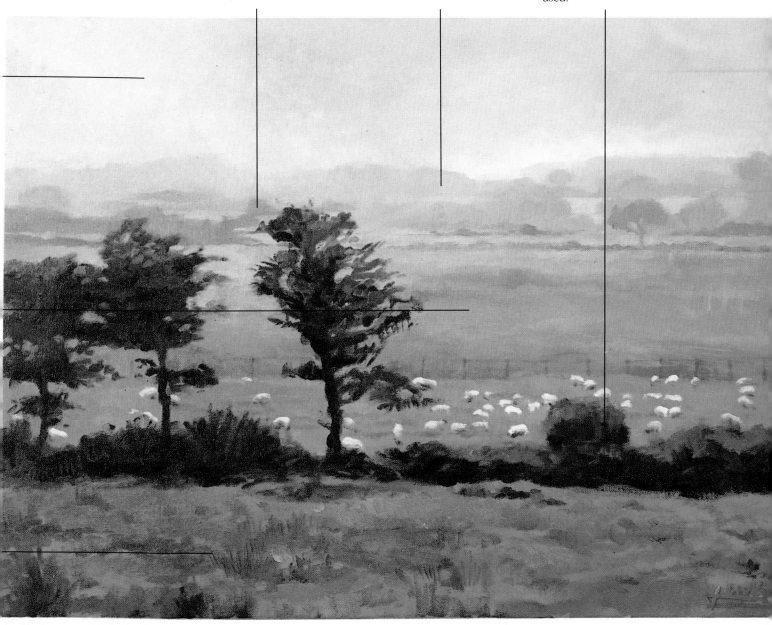

4 The variations of tone become more important as the horizontal planes are filled in. Here, the foreground is being painted with a mix of permanent green and ochre. The paint is applied with a number 12 hog-bristle brush.

5 At this point three basic tones of different chromatic characteristics can be observed: a neutral green slightly grayed for the background, a second bright green in the middle ground, and an even warmer one in the foreground.

6 The gray color of the canvas is an enormous help in a theme as subtle and atmospheric as this one. The sky is begun with a mixture of white, ultramarine, and leftovers of green from the palette.

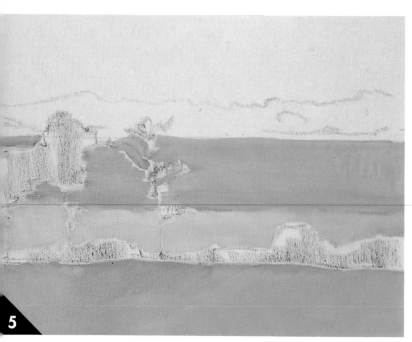

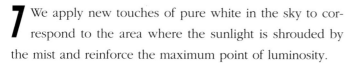

7 We apply new touches of pure white in the sky to correspond to the area where the sunlight is shrouded by the mist and reinforce the maximum point of luminosity.

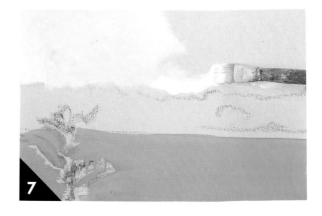

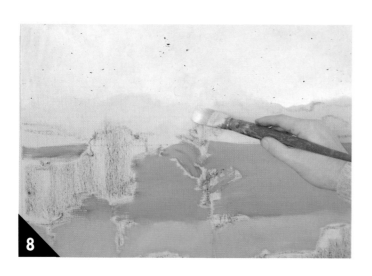

8 The brightest, but at the same time haziest, aspect of the landscape is sought out. We start on the base color of the background with the same color used for the sky, with a small amount of emerald green added. Note the way the gray-toned canvas contributes to the variation of tones for the composition's atmospheric character.

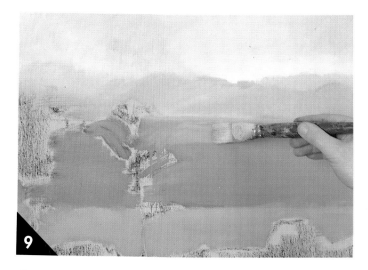

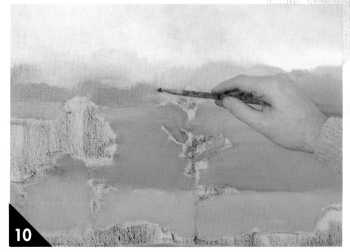

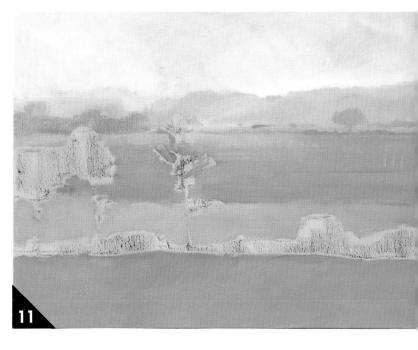

9 We continue constructing the picture with varying shades of color. The mountainous profile is painted with grayish tones verging on blue. A touch of cobalt violet is added to the previous mixture and several horizontal strokes are applied over the field to harmonize it with the background.

10 Using a tone similar to the previous ones, slightly darkening it with blue, we paint the distant trees that divide the field from the mountains. The tonal differences must be very subtle to obtain the desired atmospheric effect.

11 The painting of the background is completed. Note the desired atmosphere that has been achieved. There is still a great deal to be done, but, as we say; "What begins well, ends well."

12 Using a mixture of sap green and raw umber, we fill in the space corresponding to the bushes that divide the first two planes.

13 Using the same mixture, we define the structures of the trees. You must study them carefully to be able to correctly interpret them with your brush.

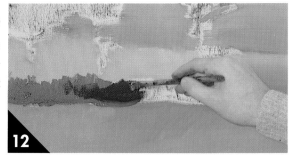

14 Without pausing, we go on to finish the remaining trees, which brings the first phase of the background painting to a close.

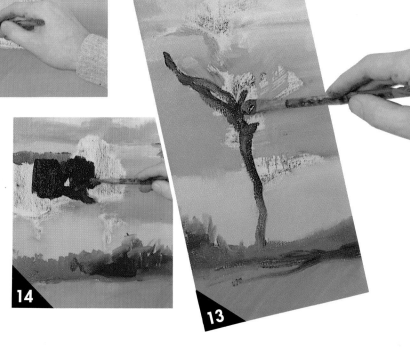

15 The general initial painting of the picture is finished. We have covered the entire canvas with appropriate hues that will allow us to add new shades of color.

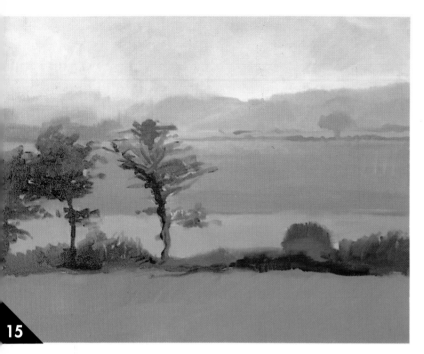

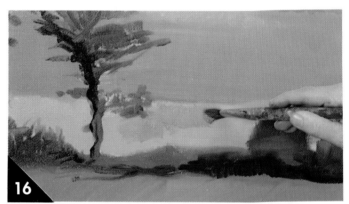

16 The intermediate tone of the field is too bright when compared with its surroundings. We correct the color with strokes of a slightly darker golden tone by adding a dab of ochre to the base color.

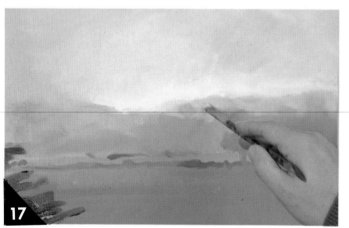

17 Moving from one side of the canvas to the other, we improve the hues and values and work on the picture in general. Now almost at the background, the shape of the trees and the atmospheric planes are defined.

18 We continue to work on the background, adding touches of warm color that harmonize with the violet hues of the lower section of the painting. The color is a mixture of white with a touch of ochre. This is then blended into the background color while it is still wet.

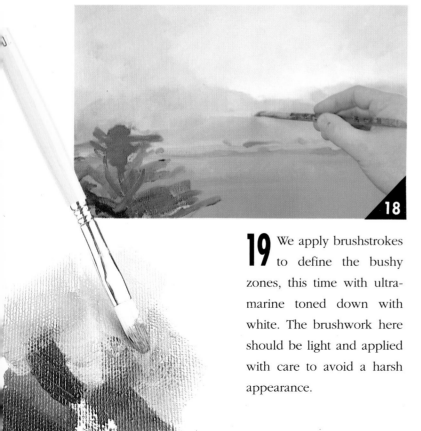

19 We apply brushstrokes to define the bushy zones, this time with ultramarine toned down with white. The brushwork here should be light and applied with care to avoid a harsh appearance.

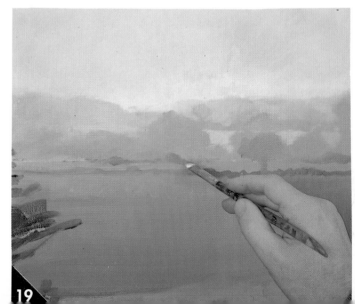

20 With a mixture of white, emerald green, and cobalt violet, we harmonize the top part of the field with the background. This hue gives us a brighter zone, influenced by the blue of the sky.

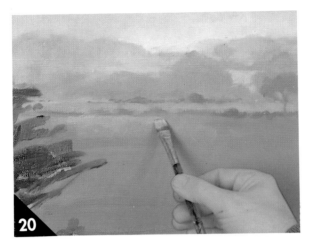

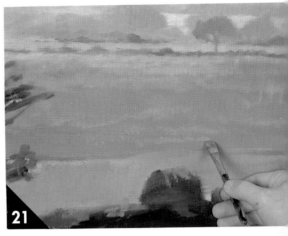

21 Working from top to bottom, we give texture to the intermediate zone of the field with a slightly lighter green, and add a few strokes of permanent green, ochre, and white to illuminate and bring the first planes closer together.

22 This is the penultimate stage. Assuming that the lower area is finished, we start on the foreground.

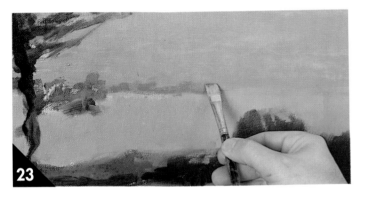

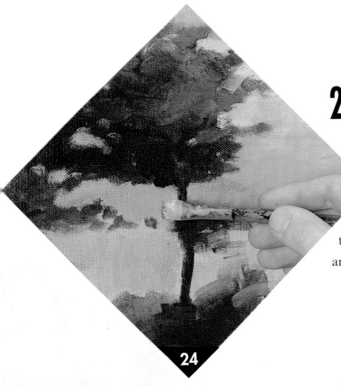

23 Now we work on the foreground, painting the thickets along the border dividing the meadows. This is done with a mixture of raw umber, permanent green, and a touch of white. The paint is laid on with short vertical brushstrokes to give a feeling of form and direction to the underbrush.

24 Now on the foreground, we paint the divisions of the fields with a broken hue made up of raw umber, permanent green, and a touch of white; this grayish tone helps the lower part to vibrate. Before making this type of adjustment, step back and look at the picture as a whole.

MIXTURES OF PAINT ON THE PALETTE

In a painting such as this landscape, we use a variety of mixes of the same color range. Therefore they can be toned and used again. There is no danger of dirtying the colors, unless we commit a serious error, which, at this point, we hope you will avoid.

25 Using a wide range of greens, composed of emerald and ochre, we begin painting the textures of the field in the foreground.

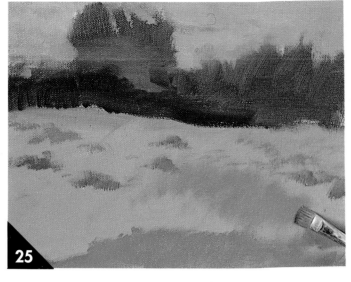

26 We define the effect of the grass and bushes with darker tones by applying vertical strokes, thus obtaining the effect of detail. Since this is the zone nearest to us, it should be painted with a loose hand.

THE CHARACTER OF THE PAINTING

The atmospheric tone of this landscape requires a much more subtle pictorial treatment than the previous paintings we have worked on. Any excessive contrasts of color or brushstrokes may ruin the harmony of the work.

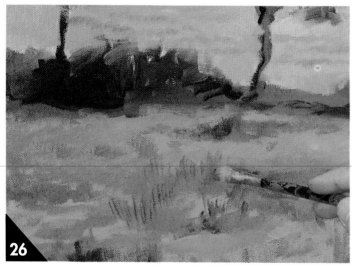

27 Note the brushwork, which adds light and texture to the upper area of the bushes with a mixture of permanent and emerald green. As we have stated previously, the brush should just caress the canvas without pressing, with broad strokes of color that move in the desired direction.

28 Now it is time to work on the final details. We add strokes of a lighter value of permanent green and ochre to the branches, giving the trees greater depth and volume.

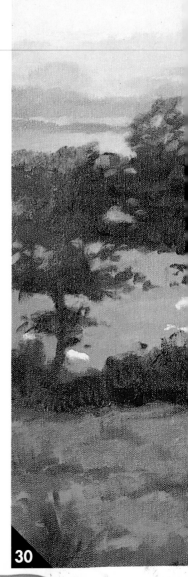

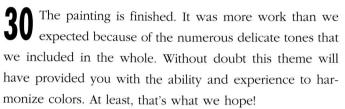

29 Thanks to the fast-drying action of the medium, we can calmly start on the sheep without fear of messing up the background. Strokes of white applied with a fine brush are enough to suggest them, and some raw umber is used for their shadows.

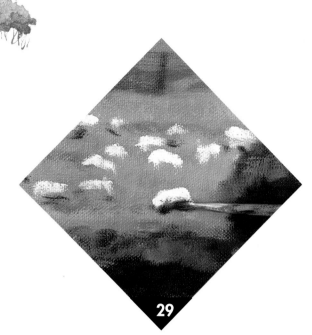

30 The painting is finished. It was more work than we expected because of the numerous delicate tones that we included in the whole. Without doubt this theme will have provided you with the ability and experience to harmonize colors. At least, that's what we hope!

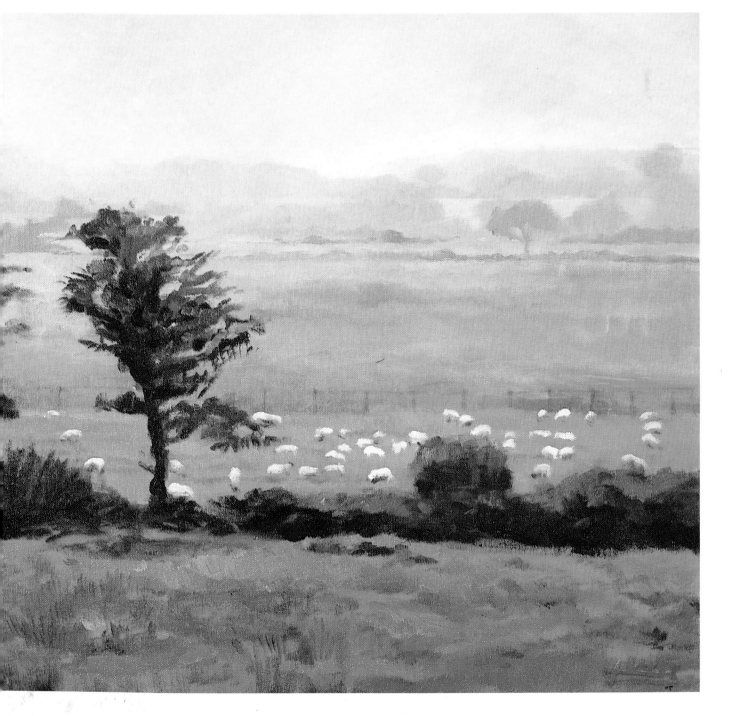

PAINTING A REFLECTED LANDSCAPE

*T*he theme we are going to tackle this time possesses notably different characteristics from the previous one. This lake scene has been painted from a barge, thus creating the sensation of painting on the water itself. The picture is so sharp and clear that it is almost impossible to distinguish the landscape from its reflection on the water; only the light breeze that produces some small ripples on the water differentiates one from the other. If you really doubt it, just turn the photograph upside down and see for yourself.

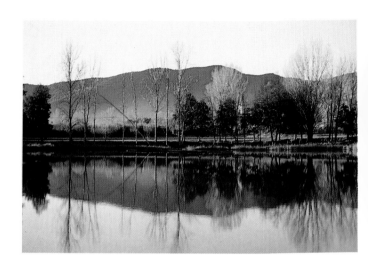

MATERIALS

• White canvas mounted on stretchers (20" × 26")

• Charcoal

• Colors: titanium white, yellow medium, yellow ochre, orange, vermilion, madder, raw umber, turquoise blue, ultramarine blue deep, emerald green, violet

• Brushes: flat hog-bristle brush number 14, flat synthetic brush number 12, ox-hair filbert brush number 8.

• Outdoor easel, palette, and palette cups

• Turpentine, rags, and newspaper

1 The main structure is drawn with charcoal. Detail is not necessary since large areas of the drawing will be covered with color.

2 Using the widest brush at our disposal to cover large areas with ease, we establish the general color of the composition, starting on the profile of the mountain with a mixture of ultramarine with a touch of raw umber toned with white.

3 Continuing to fill in this area, we add white to the color for the lightest area. As usual, the first strokes of paint are diluted with turpentine.

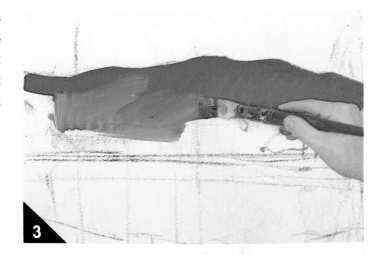

The mountain's general tone is a mixture of ultramarine with a touch of raw umber. To break the excessive sharpness, it is toned with white.

The tones of the sky vary, blending together white lightly toned with turquoise blue and a dab of orange on the left; and on the right, white and ultramarine.

The trees appear dark, in a range of mixtures of raw umber, emerald green, and ultramarine.

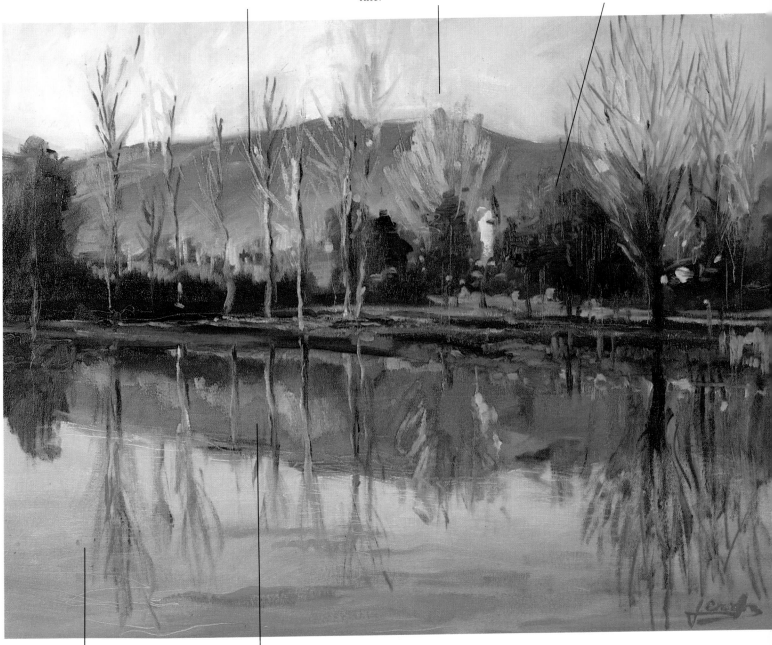

The basic color of the lake is turquoise blue, with white and a touch of raw umber to break the tone. In the darker areas, a mixture of ultramarine and violet was added.

Just like the mountain itself, the base tone of the mountain's reflection on the water was painted with ultramarine, raw umber, and white.

4 We now go on to the profile of the mountain reflected on the water by covering the entire area. As you can see, a lot of detail drawn at the beginning would have disappeared.

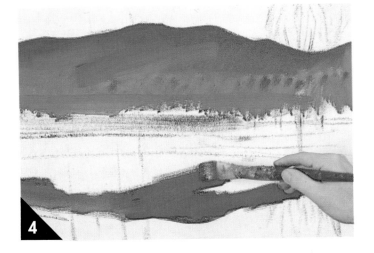

4

5 We continue to fill in the entire space, applying light dabs of color. Note that some areas in the center are left untouched. This acts as a reference for the horizon.

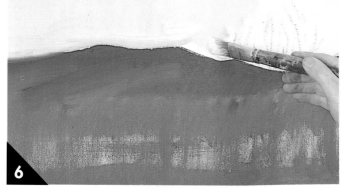

6 Since the canvas has to be covered rapidly, the sky is painted with a medium tone, a mixture of turquoise blue, ultramarine, and white. These colors will later be harmonized appropriately.

7 The same is done for the reflection of the sky on the water; the hue is the same as before, but it is toned up slightly. The base color of the nearest plane is toned with a touch of violet.

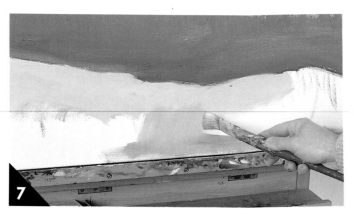

8 The general background color has been established quickly. This will aid us in applying new hues and values that will gradually take us to the end result.

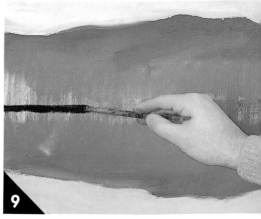

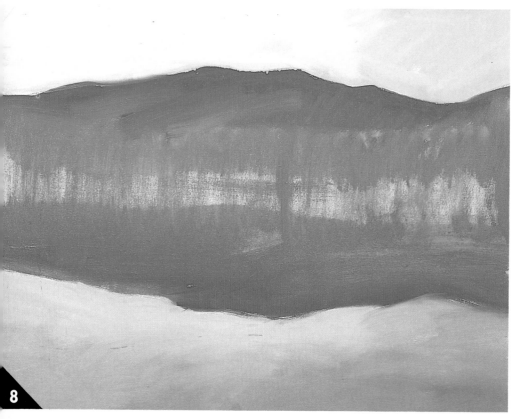

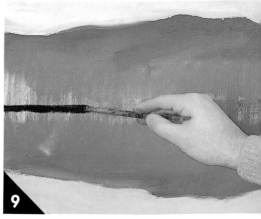

9 We paint the horizon line, which divides the upper scene from the reflection on the water, using a mixture of raw umber and ultramarine, holding the brush with a steady hand while stroking lightly across the canvas.

10 Continuing with the previous mixture—that is, raw umber toned with ultramarine—we start to define the shape of the trees, using from the start a loose brushstroke.

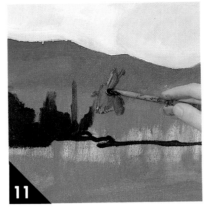

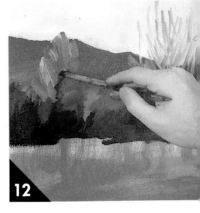

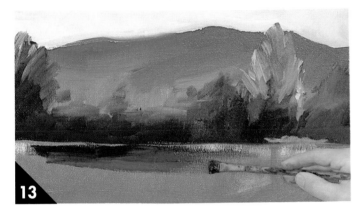

11 The painter's restlessness to advance is almost innate. It is time to change colors. This time we use an orange tone to indicate the lighter areas of the trees.

12 The first areas of color are now at an advanced stage. Certain lights from ochres and oranges have been established. Now we start on new intermediate tones using the mix of orange and raw umber.

13 We return to the shadow on the lake to paint the dark reflections in the upper zone. For this purpose, we use a mixture of ultramarine and raw umber, painting certain areas with pure ultramarine.

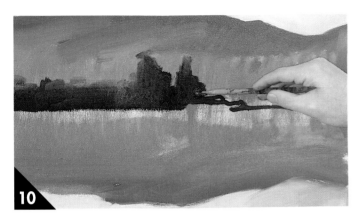

14 The second stage of the painting is dominated by somber colors. Even though we are only trying to obtain an impressionist picture, the landscape contains so many tones that there is much left to do.

TECHNICAL ASPECTS

When you paint a light tone over a still wet dark one, the stroke should be applied in a spontaneous manner and without pressing down too much on the brush. This way the two colors will not blend together. The painter has to be daring to perform this type of action. At the beginning, you might muddy the colors, but with experience and practice you will eventually overcome this problem.

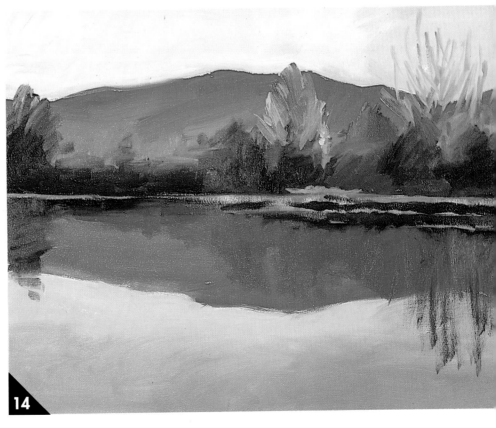

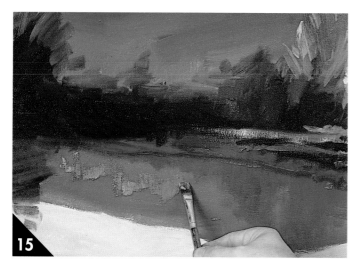

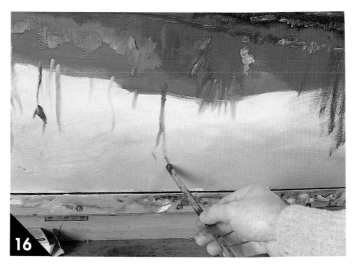

15 It is useful to squint your eyes when comparing reality with the result. With yellow ochre lightly toned with ultramarine, we reproduce the reflection of the trees on the lake.

16 Now we paint the reflection of the trees on the water with a mix of ultramarine blue and raw umber. Paint from top to bottom without pressing to let the stroke flow.

17 We return to the trees, this time painting with pure yellow ochre that we deliberately blend with the background tone, while enhancing the strokes to reflect the effects of sunlight. We take advantage of these mixtures to paint those areas where these tones should be applied.

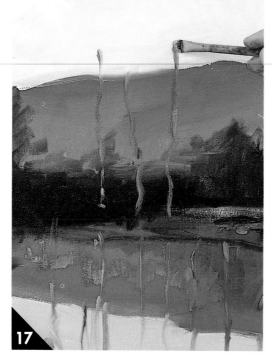

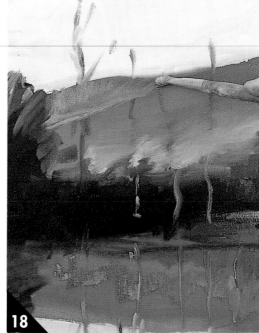

18 Again we break up the yellow ochre by toning it with ultramarine and white to highlight the area on the left that receives the most direct sunlight.

19 Because this landscape is being painted in the fall, we apply some gold to the vegetation. To bring out the color quality of the landscape, we add luminous touches of pure yellow ochre.

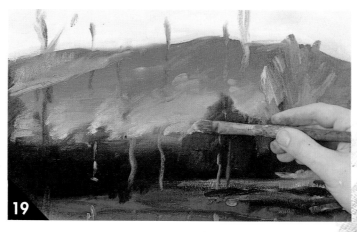

20 Returning yet again to the trees to give the branches their definitive shape, we use yellow ochre and white toned with emerald green. To get the right effect, we keep the strokes loose and follow the direction of the branches.

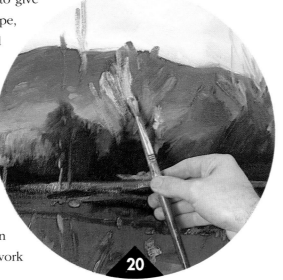

21 Using a fine brush loaded with raw umber, we refine the reflections on the lake. Don't concentrate on touching up any one particular area; work on everything at the same time.

HOW TO OBSERVE A THEME

The best way to determine the forms and colors of your landscape or any other scene, so you can transfer them to your canvas, is to squint your eyes. This helps to simplify the scene, making you aware of the most important values and highlights.

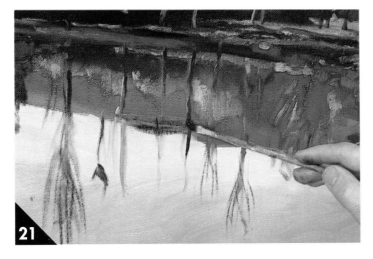

22 The painting is nearly ready. Little by little we have captured the atmospheric light correctly. The only thing left is to add some subtle nuances of color.

23 We begin on the final details, warming up the reflection of the trees. The brush should merely glide over the canvas.

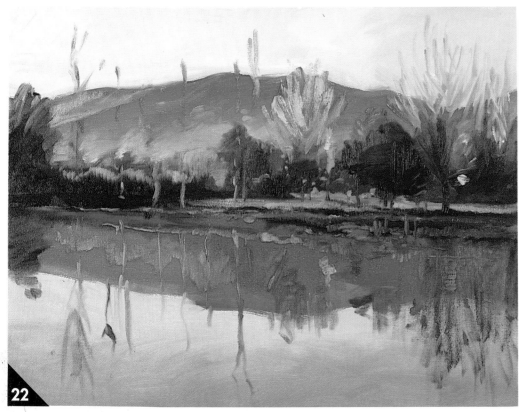

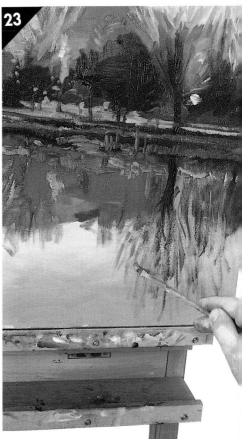

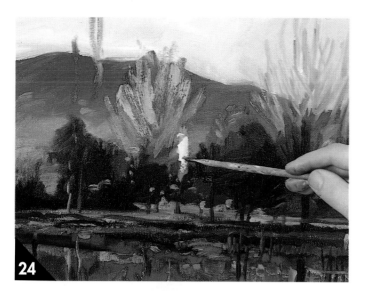

24 Some houses can be glimpsed through the trees and bushes. Excess detail should be avoided at all costs, since this will spoil the rest of the picture; the forms are merely suggested with brushstrokes of pure white.

25 Applying sweeping strokes of ultramarine with a touch of white, we reproduce the sensation of the ripples created by the light breeze blowing across the foreground of the lake.

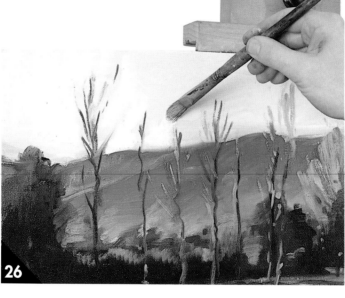

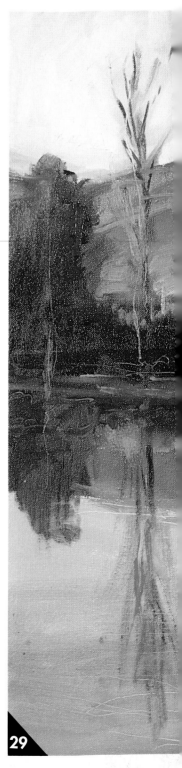

CLEANING THE PALETTE AND BRUSHES

When you finish your picture, and you are sure you won't paint again for several days, clean the palette and rinse the brushes in turpentine. When you get back home, wash the brushes with soap and water to remove any remaining color.

26 Remember that light changes with the passing of the day. Because at this point the light has become brighter, we apply several touches of white to the sky.

27 Use the sgraffito technique to create texture and make the reflections ripple.

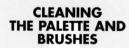

28 To conclude the painting, we reinforce and redefine the branches with loose but precise brushstrokes of yellow ochre and carmine.

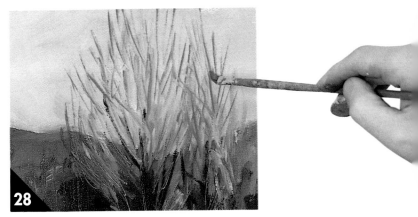

29 The question now is whether to continue or leave the painting as it is. We consider the picture as a whole. The spontaneous and direct nature of the work has been obtained, so we decide to leave it.

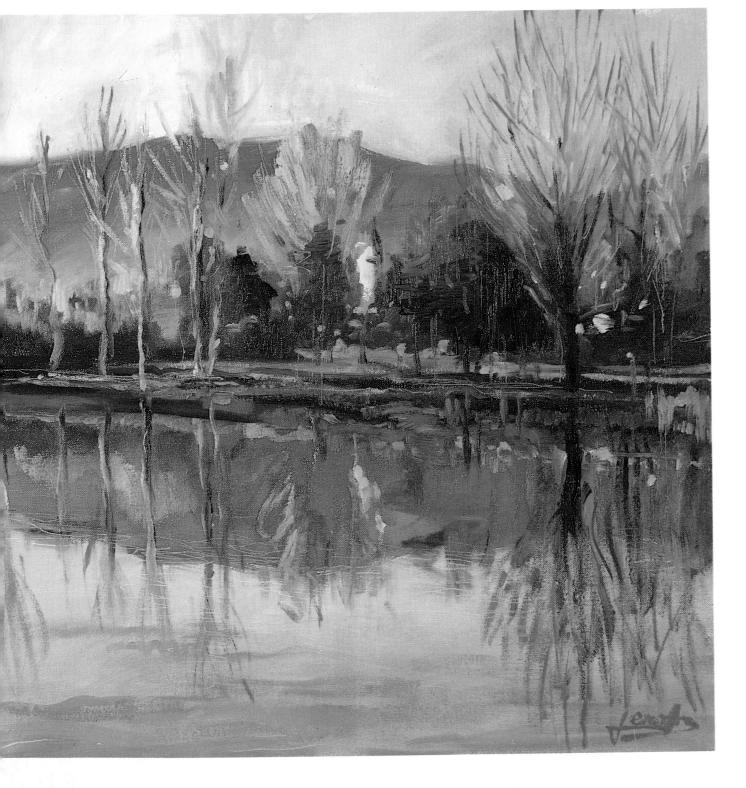

PAINTING WITH A PALETTE KNIFE

*T**he composition we are going to paint with a palette knife has deliberately been altered. Compare the photograph with the finished painting on the right; the horizontal spaces have been reduced, while the vertical ones have been increased. Since the theme is a landscape, it should be relatively easy to paint. This exercise will prove both enlightening and fun. Good luck!***

MATERIALS

- White canvas mounted on stretchers (26" × 20")
- Charcoal
- Number 14 hog-bristle brush
- Palette knife
- Colors: titanium white, yellow medium, cadmium orange, yellow ochre, vermilion, raw umber, turquoise blue, ultramarine blue light, permanent green, emerald green, cobalt violet
- Palette with palette cups
- Outdoor easel
- Rags and newspaper
- Turpentine

The background color of the sky was painted with a mixture of turquoise blue and white. The clouds were painted with ultramarine toned with white. Pure white was applied with a palette knife in the lighted zones of the clouds.

The nuances of color seen on the mountain were painted with a mixture of ultramarine, cobalt violet, orange, and white, with intervening tones of emerald green, violet, and orange, which add bright accents.

The lightest areas of the landscape were basically composed of permanent green with some touches of orange, violet, and emerald green toned down with white.

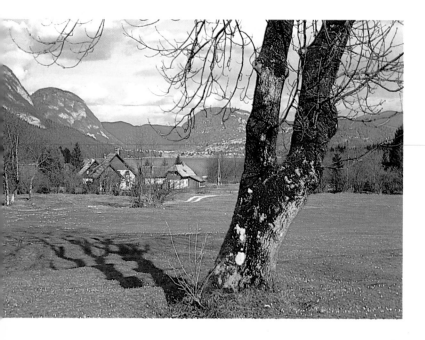

2 We continue filling in the background, alternating the mixtures of ultramarine and white, neutralized with orange. We are going to establish the base color in a very general way, since the final color will be added later with the palette knife.

1 We will not dwell on the drawing but get straight down to painting. Before using the palette knife, the first areas of color should be applied with a brush.

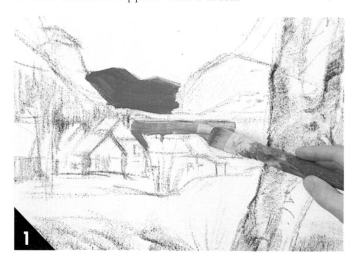

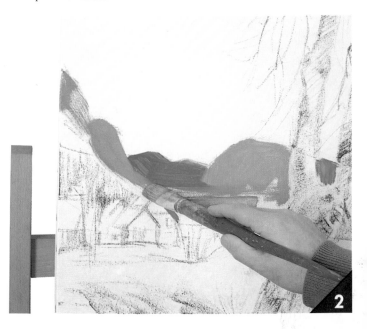

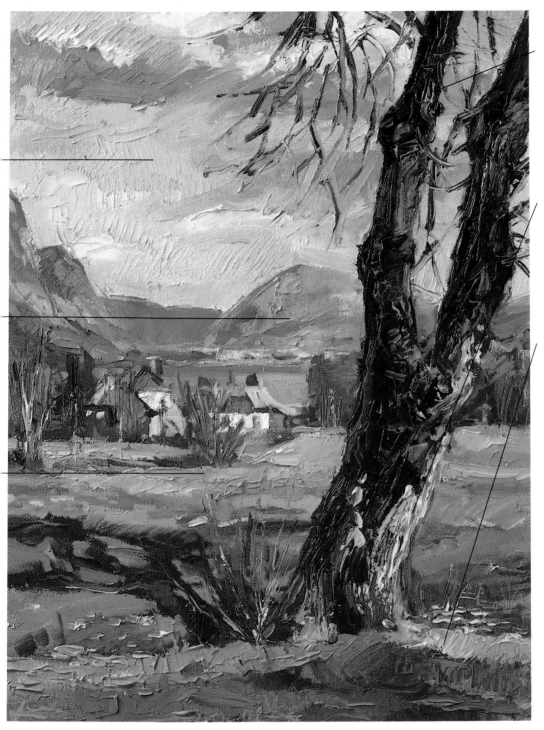

A mixture of emerald green, raw umber, and carmine was used to paint the tree. Toning down the colors and changing them slightly introduced variations of intermediate tones.

For the areas of the tree where the bark is highlighted, a mixture of white, emerald green, and raw umber was used. The texture was created with the use of the palette knife.

As you can see, the color of the ground below the tree is composed of direct strokes of yellow, violet, and orange.

4 The intermediate spaces are filled in, adding ochre to the previous mixes. As you can see, we are not too worried about the precise color at the moment; it will be corrected later on.

3 Now we paint several dabs of emerald green and white blended with the ultramarine. Next we apply some strokes of lightly toned ochre, blending them with the previously painted areas.

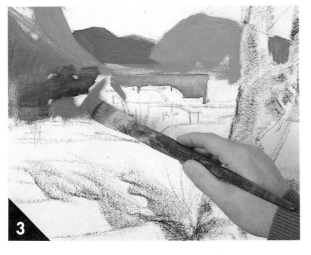

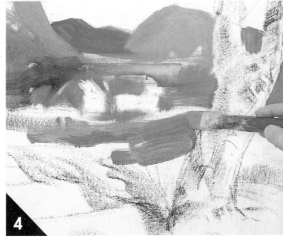

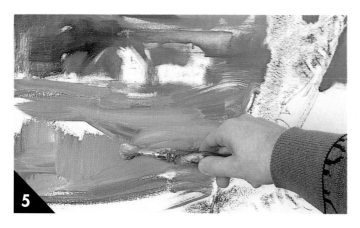

5 We make some necessary changes in the color, mixing permanent and emerald green and blending them with the greenish ochre, thus creating new tones.

6 Note the appearance of our painting. These are not the final colors, but they are all the result of slight changes in the previous mixtures on our palette.

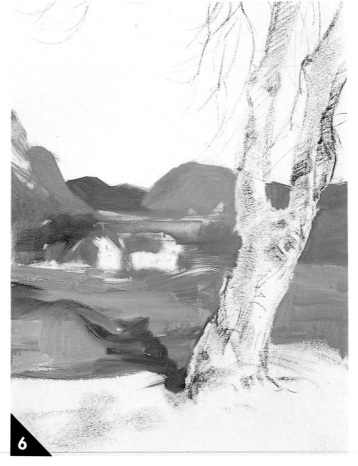

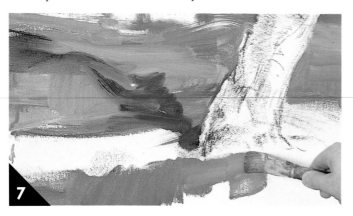

7 Now it is time to paint the foreground, leaving the area of the shadow cast by the tree. These khaki colors have been obtained from the blends on the palette.

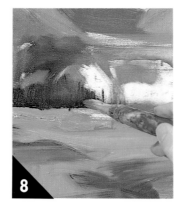

8 Working on everything at the same time, we fill in the canvas as quickly as possible. In this case cobalt violet is blended with previously applied greenish tones.

9 Now that the entire part of the lower area has been covered, we start on the sky with a mixture of white and turquoise blue. The brush is first cleaned off in turpentine to avoid dirtying the color.

10 We continue to construct the sky by harmonizing it with slight variations of the same color. Here we can see a mixture of ultramarine and white to begin the clouds.

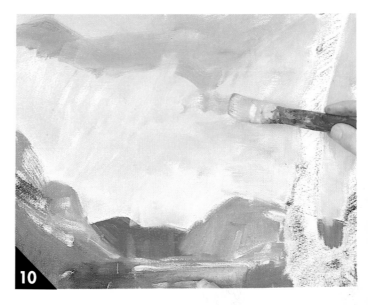

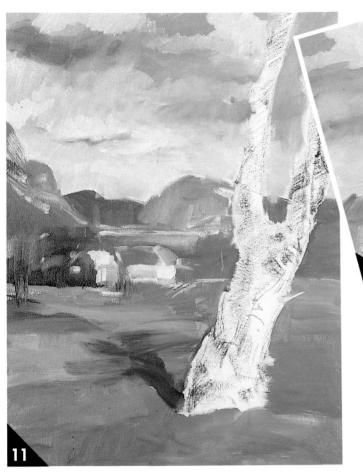

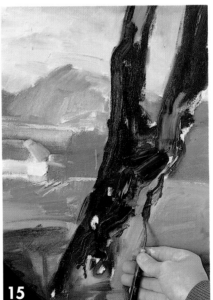

12 The first strokes of the tree correspond to the intermediate tones we see in them. Looking at our palette, we use one of the mixtures of color already there, in an intermediate hue and value.

13 We continue developing the form of the tree. Now we need a stronger and darker tone to outline its shape; we use an application of pure raw umber.

11 The second stage of the picture is completed. The entire canvas has been painted with colors and values that will guide us to the final result. The only remaining thing is the tree; without further delay, we get down to work.

14 Now the first strokes of color have been applied to the tree. We paint a few lines of raw umber and violet to define the shadow cast by the tree.

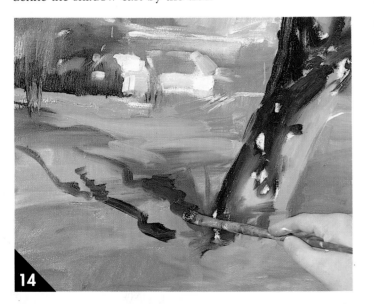

THE PALETTE

Normally, when painting, you build up a range of different hues on your palette. These can be taken advantage of by mixing them again, as long as the color is similar to your needs. At one point, however, you will have to clean the palette to mix new colors.

15 It's time to clean the palette because we are going to work with new colors. We take advantage of the leftovers, mixing and applying them onto the tree trunk to give it texture.

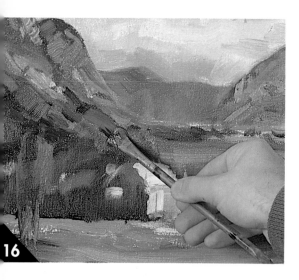

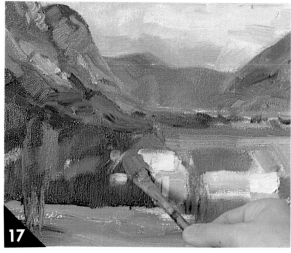

17 We paint the rooftops of the houses with accents of color composed of orange, vermilion, and a touch of permanent green to harmonize them with their surroundings.

16 Work with the brush continues. New tones, obtained from a mix of emerald green and a touch of carmine, are added to give form and depth to the landscape.

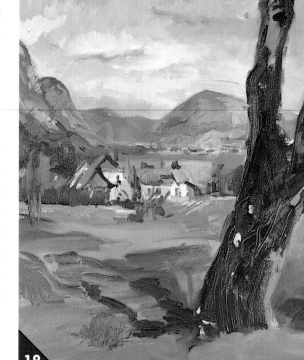

HOW TO USE THE PALETTE KNIFE

When you paint with the palette knife, you have to paint with the exact color, obtained from a perfect mixture on the palette. Areas of impasto must be clean, precise, and decisive in order to produce texture and volume. Make sure you don't mix the paint with surrounding colors, which will most likely destroy the sharpness that this technique entails.

18 As you can see in this third stage of the picture, we have been adding light and fresh color to the undefined base tones in the previous stage. There are still a few things to correct with the brush before going on to paint with the palette knife.

20 Creating some light impastos, we continue to vary the color of the foreground with a mixture of emerald green and orange.

19 New bright greens are applied, alternating between ochre and permanent green lightly toned with orange. The aim of this stage is to refine the form and color in order to prepare a background on which to add areas of impasto—thick areas of paint—with the palette knife.

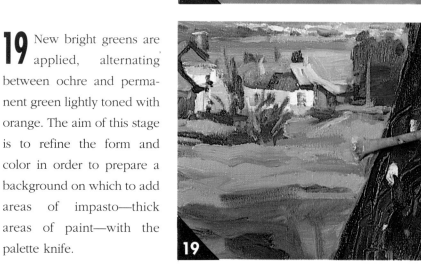

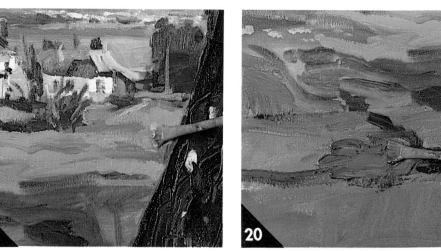

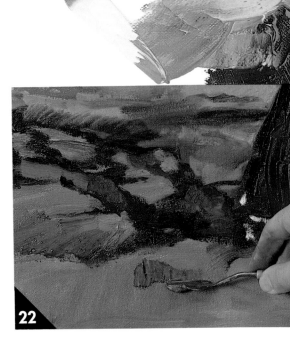

21 We return to the shadow cast on the ground by the tree and use an ultramarine and madder mix. It is essential to correctly define the form, since the palette knife will be used more for adding volume than for defining shapes.

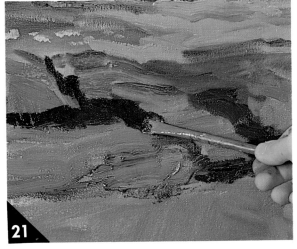

22 Finally we begin to refine and add the finishing touches with the palette knife. Note the way it is held and used. The color is applied and scraped in the direction most appropriate to the desired effect.

23 Lay the color on from top to bottom, with resolute and uniformly thick areas of impasto. Here we have used pure raw umber, deliberately intermixing it with the previously applied green.

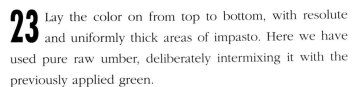

24 We work rapidly, adding texture and giving the forms volume with the palette knife. Here we apply a mixture of turquoise blue, cobalt violet, and white.

25 Naturally the sky receives the same treatment. Here we apply a mixture of ultramarine and white.

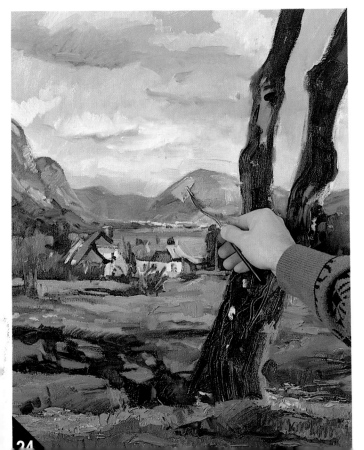

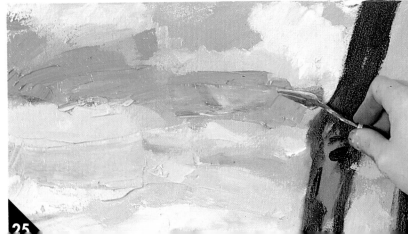

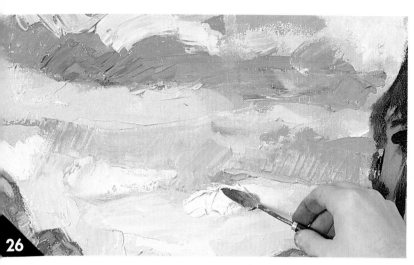

26 We continue to texture the sky and brighten it with some pure white in the luminous zones of the clouds. Note the work of the palette knife in giving the sky character.

27 We touch up the foreground with strokes of white applied with the side of the palette knife, this time to suggest the wild flowers growing at the foot of the tree. These details must be painted with care so as not to overdo them.

28 To finish, we paint the tree with a mixture of raw umber and violet, making sure that the strokes laid on with the palette knife continue to define the form of the tree.

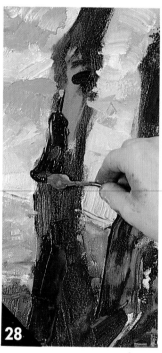

29 Having applied the impastos on the tree with its darker tones, we add texture to the lighter areas and the bark of the tree with warm grays and some pure white. Note that the palette knife must be moved in the right direction so that the heavy impasto takes on the desired shape.

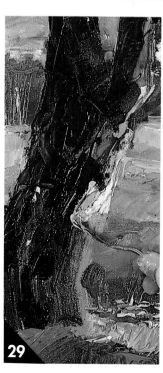

30 The only job remaining is to add detail to the trees's top branches by applying the color with the edge of the palette knife.

31 On the right you can see the finished work. The palette knife can produce spectacular effects, perhaps better than the traditional brush, but it is a risky technique that requires skill.

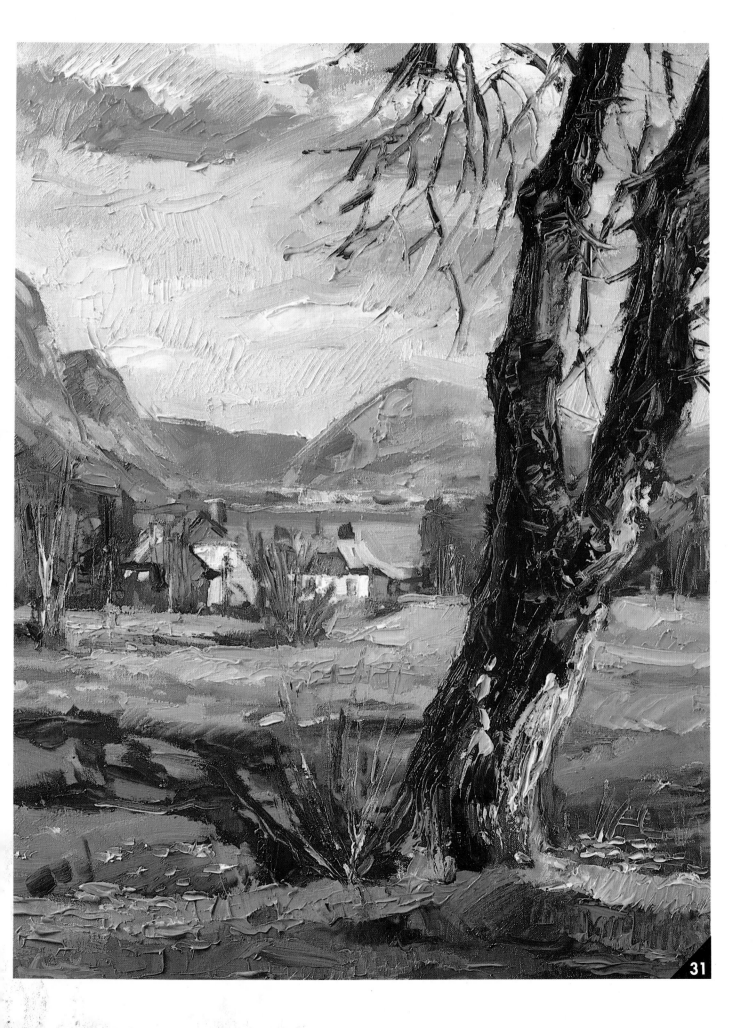

ACKNOWLEDGMENTS

I would like to sincerely thank Jordi Vigué, editing director of Parramón Ediciones, for inviting me to write this book. It has given me great satisfaction to have the chance to share my knowledge of oil painting with others through this book of exercises. Thanks go to all those who contributed their ideas, advice, and help in putting this book together. Their assistance was invaluable in attaining such a high standard of quality.

Special thanks go to Josep Guasch, who understood what I was aiming at and provided the corresponding design; to Jordi Martínez, who helped in resolving the little hiccups along the way; to the photographers at Nos & Soto, for their patience and understanding during painting sessions we shared together; and finally, to everyone else who contributed to making this magnificent book a reality.

A million thanks to all of them.

Miquel Ferrón